THE SECOND WAVE

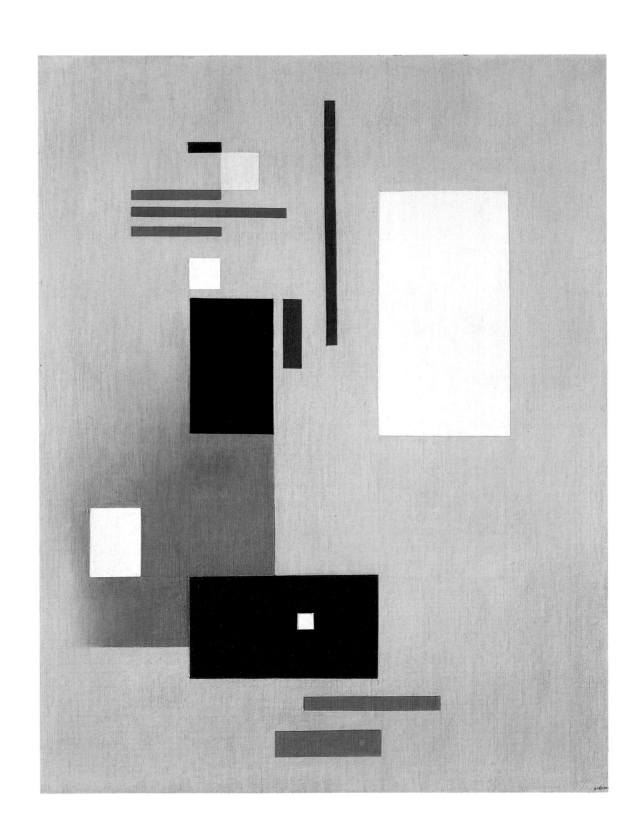

THE SECOND WAVE: AMERICAN ABSTRACTION OF THE 1930S AND 1940S

SELECTIONS

FROM THE

PENNY AND

ELTON YASUNA

COLLECTION

by SUSAN E. STRICKLER and ELAINE D. GUSTAFSON

WORCESTER ART MUSEUM · WORCESTER, MASSACHUSETTS

This catalogue was published on the occasion of the exhibition *The Second Wave: American Abstraction of the 1930s and 1940s, Selections from the Penny and Elton Yasuna Collection,* organized by the Worcester Art Museum. The exhibition was on view at the Worcester Art Museum, September 12–December 1, 1991; the Samuel P. Harn Museum, University of Florida, Gainesville, February 23–April 12, 1992; and the Delaware Art Museum, Wilmington, October 3–November 29, 1992.

W♦M

Worcester Art Museum
55 Salisbury Street
Worcester, Massachusetts
01609

Designed by Gilbert Associates.
Printed in the United States of America
by LaVigne Press.

Front cover:
Charles Biederman.
Heads, New York, June, 1935
(cat. no. 44)

Frontispiece:
Jean Xceron, *White and Gray, No. 256,* 1941
(cat. no. 42)

TABLE OF CONTENTS

The study, interpretation, and presentation of the achievements of American art have been an important part of the educational mission of the Worcester Art Museum during its ninety-five-year history. Because the permanent holdings of the Museum are particularly rich in American paintings of the seventeenth, eighteenth, and nineteenth centuries, we are especially pleased to have this opportunity to present an exhibition focusing on the accomplishments of Americans working during the mid twentieth century through examples from the collection of two longtime friends, Penny and Elton Yasuna.

For more than thirty years the Yasunas have enthusiastically collected American painting. Like many collectors, they initially had wide-ranging interests, from the Hudson River School to The Eight and the American modernists. During the last ten to fifteen years, however, the Yasunas have astutely and instinctively concentrated on the work that has appealed to their taste. Their collection now focuses on several groups of artists who participated in the dynamic transition in American art from the traditional dominance of realism to an international forum of abstraction and nonobjectivism. With characteristic vigor, they searched for the works of modernist painters associated with the art colony at Provincetown, near their home on Cape Cod, as well as of the American Abstract Artists, who were active in New York City, and the Transcendental Painting Group of New Mexico. When the Yasunas began their search, relatively few others shared their foresight. As their passion and knowledge deepened, they sought out many of the artists in an effort to learn more about the period. Consequently, the Yasuna Collection reflects a marvelous intimacy and immediacy, encompassing studies and finished works in the form of small drawings, collages, watercolors, and oils that reflect the artists' presence and creative process or that sum up the artists' fully conceived intentions.

The current exhibition and catalogue focus chiefly on two progressive groups – the American Abstract Artists (AAA) and the Transcendental Painting Group (TPG) – who were active during roughly the same period, the late 1930s and early 1940s. The Worcester Art Museum is proud to present, in addition to a survey of work by the AAA (about whom there has been an increasing interest in recent years among scholars, collectors, and museums), the most comprehensive traveling exhibition of the TPG since its founding in 1938. Nine of the ten members of the latter group – excluding the elusive Robert Gribbroek – are represented in this show. We are indebted to the Yasunas for their part in sharing this facet of American modernism with a broad national audience.

I also welcome the opportunity to thank the dedicated staff of the Museum for their efforts in producing this exhibition and catalogue. The project has been overseen by Susan E. Strickler, Director of Curatorial Affairs and Curator of American Art. She has been ably assisted by Elaine D. Gustafson, whose internship in American art has been generously supported by the National Endowment for the Arts. Together, they have authored this catalogue, which not only documents highlights from an intriguing private collection but also summarizes the events of a fascinating chapter of American art.

James A. Welu
Director, Worcester Art Museum

Since the turn of the century the evolution of American art has centered around a dynamic counterpoint between artistic groups or movements attached to a long-standing national tradition of realism and those with a desire to participate in the international forum of nonrepresentational expression. The first two decades of this century witnessed the achievements of European artists such as Paul Cézanne, Wassily Kandinsky, Kasimir Malevich, and Pablo Picasso, and the progression of movements such as Cubism, Suprematism, and Neoplasticism. This international vanguard broke its dependence on the visible world for inspiration, looking instead toward purely formal aesthetic concerns. In the search for an expression reflective of the growing international stature of their own country, watchful progressive American artists found a new creative energy abroad. Consequently, the first wave of abstraction reached the shores of the United States during the 1910s, as the young Americans who had witnessed firsthand these exciting developments brought back from their travels a new visual language.

The reception these artists found in New York was mixed at best. Several, including Arthur Dove, Marsden Hartley, John Marin, Georgia O'Keeffe, and Abraham Walkowitz, got support and encouragement from the dealer and impresario Alfred Stieglitz, and other modernists were offered shows at the forward-thinking Daniel and Montross galleries. The landmark Armory Show of 1913 attempted to promote the work of these young Americans alongside the accomplishments of their European mentors, but the public remained largely skeptical, preferring the familiarity of realism. With the disillusionment following World War I, the nation entered a period of retrenchment, and the Social Realists and the regionalists gained popular acclaim as the tide of American modernism subsided during the 1920s.

This catalogue and the exhibition it accompanies focus on the second wave of nonrepresentational art in America, which began gaining momentum in the mid 1920s and early 1930s as a new generation of Americans, born mostly between 1900 and 1915, rediscovered the avant-garde movements in Europe. There are obvious parallels between the first and second waves. In both instances, Americans drew their inspiration from European precedents. For both generations a world war served as an important catalyst in drawing together an international artistic vanguard, and especially in bringing Europeans to the relative safety of New York. And, as outsiders to the artistic mainstream, progressive Americans of both generations struggled to be heard over the dominant voice of realism. Some Americans active in the first wave — most notably Jan Matulka and Stuart Davis — were important teachers and mentors

for their younger compatriots, who were not unaware of the avant-garde activities of the 1910s. However, though the first wave of modernism had subsided with a resurgence of realism, the second wave gave rise in the mid 1940s to a succession of new forms of abstraction — most notably Abstract Expressionism — which marked the emergence of New York, rather than Paris, as the foremost international art center. Although realism had hardly faded from the public eye by the close of World War II, the validity of nonrepresentational art was no longer so widely disputed, owing in large part to the persistence of groups such as the American Abstract Artists (AAA) and the Transcendental Painting Group (TPG), both of whom participated in the second wave.

In discussing the evolution of nonrepresentational art in both Europe and America during the 1930s and 1940s, issues ultimately arise over the use of the terms *abstract* and *nonobjective* to describe the increasingly reductive aesthetics of modern art. A plethora of alternate adjectives — concrete, nonrepresentational, nonfigurative, pure, and absolute — were used by the artists themselves. But even though artists often debated the semantics of these terms, they were essentially concerned with philosophically differentiating abstraction and nonobjectivism. Realism depends solely upon observation of the real world, but abstraction finds its basis in the artist's liberal interpretation of the physical world through the manipulation of formal devices such as the generalization of recognizable form and the application of expressive, rather than naturalistic, color. The greater the generalization, the more abstract the composition. The nonobjective artist delves into a realm farther removed from the physical world than abstraction and works completely with invented compositional elements that have no reference to the visible world. The vocabulary of the nonobjective artist can often relate to the properties inherent in his medium, to the creative process itself, or to the expression of a concept, an emotion, or a sensation.

Both the AAA and the TPG wrestled with finding nomenclature that would encompass the variety of approaches and styles of their members, and both incorporated statements in their published manifestos, which noted the inadequacy of any one term. The AAA preferred a liberal interpretation of the word *abstract,* but the TPG chose a new term, *transcendental,* recognizing that neither *abstract* nor *nonobjective* was adequate. In fact, both groups included artists working in both abstract and nonobjective idioms, and within each group, there was a gradual shift from abstraction toward the nonobjective as the 1940s approached. Interestingly, the farther afield the artists moved from the physical world for their inspiration, the larger the

question loomed of the social relevance of their art; this issue will probably never be resolved. As the artist can argue that abstraction and nonobjectivism are vehicles with which to address society at a more profound level than realism, the critic can dispute the ability of the rarefied and complex language of abstraction and nonobjectivism to speak effectively to uninitiated audiences. Perhaps more pertinent than the outcome of such debate is the critical importance for artists to continue their search for new visions and vocabularies and offering new insight into the ways a society can perceive the world in which it lives.

Susan E. Strickler
Director of Curatorial Affairs
Curator of American Art

ACKNOWLEDGMENTS

The fruition of any exhibition and publication is the result of the efforts of many generous individuals. Though we take full responsibility for the choice of content and for its interpretation, we welcome this opportunity to acknowledge the support of those who offered guidance and assistance along the way.

Of the many who contributed to our research, several deserve special mention. Virginia Mecklenburg, Chief Curator of the National Museum of American Art, near the outset of our project magnanimously shared her extensive files on the American Abstract Artists; her articulate exhibition catalogue *American Abstraction 1930–1945: The Patricia and Phillip Frost Collection* was also an invaluable reference. Joe Traugott, Curator of the Jonson Gallery at the University of New Mexico, Albuquerque, and especially Tiska Blankenship, Assistant Curator, generously opened their rich files on Raymond Jonson and the Transcendental Painting Group; these files and the painting collection of the Jonson Gallery are rich resources that have only begun to be tapped. Artists Florence Miller Pierce and William Lumpkins graciously agreed to be interviewed, and Ed Garman was a patient, articulate correspondent. These three members of the Transcendental Painting Group offered important recollections and crucial information on their own work and about their colleagues. We are grateful to Harriette and Martin Diamond, important dealers who knew many of the artists; the Diamonds opened their files and patiently answered our many questions. Pamela Esther Nask kindly shared information she had gathered on Frederick Kann.

Numerous people reviewed various parts of the manuscript. Among the artists and their families who assisted us were Andrew Bolotowsky, Stephen B. Browne, Alice Swinden Carter, Herzl Emanuel, Dwinell Grant, Emily Mason, Ralph Rosenborg, Verna Sennhauser, and Frederick Whiteman. Colleagues in the museum field who have our thanks include Lawrence Campbell, Ward Jackson, James Moore, and MaLin Wilson.

For the handsome design and production of this catalogue we extend our thanks to Gilbert Associates of Providence, Rhode Island. The manuscript was ably edited by Robin Jacobson. We also thank Marianne Gibson and Deborah Sosin for proofreading the manuscript.

The contributions of our colleagues on the staff of the Worcester Art Museum can hardly be overestimated. David Acton, Curator of Prints and Drawings, very generously contributed four entries to this catalogue in spite of a heavy schedule of commitments. Ron White provided excellent photography of the collection. Joanne Carroll typed the manuscript while juggling a variety of other duties. We also extend our appreciation to Sally Freitag, Registrar, not only for

her organizational efforts related to this exhibition but also for her deft skills in helping oversee many daily curatorial activities during the preparatory phases of this project. Our thanks also go to John Reynolds, Chief Preparator and Exhibition Designer; Cynthia Gilliland and John Rossetti, Preparators; Kathy Berg and Pauline McCormick, Librarians; Jennifer Spohn, Michael Duffy, and Judith Walsh, Conservators, who treated many of the paintings and drawings; Sandra Petrie Hachey, Coordinator of Photographic Services; and Dawn Rogala, Director of Publications. We are very appreciative of the support of James A. Welu, Director.

Finally, we wish to express our deep appreciation to Penny and Elton Yasuna for sharing their collection, their enthusiasm, and their knowledge of the artists and the period, and for their support in making this publication possible. Their joy of collecting has been an inspiration to us.

Susan E. Strickler
Elaine D. Gustafson

EXPLANATION OF THE CATALOGUE

General Arrangement

Most of the works are arranged within two major sections by virtue of the artist's membership in either the American Abstract Artists or the Transcendental Painting Group; three artists (Biederman, Scarlett, and Storrs) who did not belong to either group are listed as *Independents* in a section immediately following that of the American Abstract Artists. Within each section, works are arranged alphabetically by artist's surname.

Title and Date

If a title is unknown, the work is listed as *Untitled.* If the date of a work is not documented, it has been estimated based upon stylistic attributes.

Dimensions

The size of the support is given in both inches and centimeters, with height preceding width. For a few of the works on paper, the image differs significantly in size from the support, so both the image and sheet sizes are given.

Inscriptions

All inscriptions (including signatures and dates) on the recto and important inscriptions on the verso and on the frame or stretcher are included. Slashes are used to indicate lineation.

Abbreviations

Organizations frequently cited throughout this publication include:

AAA American Abstract Artists
MoMA Museum of Modern Art, New York
TPG Transcendental Painting Group
WPA Works Progress Administration

The following initials appear at the end of a few entries contributed by writers other than those previously credited in the table of contents:

DA David Acton
EDG Elaine D. Gustafson
SES Susan E. Strickler

Selected References

Because the list of references is selective, those sources that provide significant additional bibliographic material are marked with an asterisk.

Publications frequently cited in the notes and selected references include:

Lane and Larsen

John R. Lane and Susan C. Larsen, ed. *Abstract Painting and Sculpture in America, 1927–1944* (exh. cat.). Pittsburgh and New York: Museum of Art, Carnegie Institute, in association with Harry N. Abrams, Inc., 1983.

Mecklenburg, *Frost Collection*

Virginia Mecklenburg, *American Abstraction 1930–1945: The Patricia and Phillip Frost Collection* (exh. cat.). Washington, D.C.: National Museum of American Art, Smithsonian Institution, 1989.

A BRIEF HISTORY OF THE AMERICAN ABSTRACT ARTISTS

The formation of the American Abstract Artists (AAA) in 1937 was the single most important effort of vanguard artists in the United States during this era to bring to public attention the most current progressive tendencies in the art of the nation. The achievements of this group loom that much larger when taking into consideration its birth in New York City, then a tumultuous setting in which people were coping with the effects of economic depression and the impending outbreak of world war. The city not only provided a unique social and cultural context that fostered this radical association, but also cast a reflection of the struggle of the nation with its cultural identity. As the foremost artistic center in the United States, New York drew thousands of artists of diverse backgrounds into its fold, creating a rich cultural fabric. The complexities of this melting pot, however, made it all the more difficult for artists to rise above the mainstream and gain visibility, much less public acceptance. The future members of the AAA found themselves wedged between the cherished tradition of American realism and the perception of the informed New York art world that European modern art was superior. At a time of economic and political crisis, the American public, critics, and museums preferred the regionalists' and the Social Realists' more familiar, narrative styles for depicting the essential values of American life. Since the 1910s Europeans had been acknowledged by critics and museums as the leaders in the progressive movements of abstraction and nonobjectivism. Although many young American abstract painters had participated in the avant-garde artistic circles of Europe, they could hardly claim to be the innovators of these tendencies, a factor that contributed to their diminished status at home. Ironically, these conflicts would come to serve as catalysts for this group of American activist artists to band together in order to gain recognition. Only in the last decade or so have historians begun to chronicle the history of the AAA; this article is but a refrain of their work.[1] The evolution, mission, and legacy of these artists in the rise of American art as a dominant international force are now deservedly receiving proper recognition.

Although the official formation of the AAA dates to January 1937 in New York, the diverse factors and influences that led to its founding not only hark back a decade but also extend to sources in Europe. The art world of Paris during the 1920s and 1930s provided an influential training ground for many Americans. Since the evolution of Cubism in the 1910s, Paris had emerged as the foremost center of international art, and especially as the threat of Nazism increased, the French capital had become a refuge for major European artists, including those working in a diversity of abstract and nonobjective styles. Emblematic of the artistic coterie

1
The selected bibliography of this catalogue lists the major recent scholarly studies of the AAA group – by such historians as Susan C. Larsen, Richard Lizza, Virginia Mecklenburg, and Thomas Tritschler – on which this author generously drew.

drawn from all parts of Europe was the formation of artists' groups such as Cercle et Carré, in 1931, and the more influential Abstraction-Création, Non-Figuratif, in 1932. Both were important vehicles through which proponents of Cubism, Neoplasticism, Constructivism, and the Bauhaus exhibited together. Through its shows and publications, Abstraction-Création remained a significant force in the Parisian art world until 1936, at one point drawing a membership of nearly four hundred. In the pages of its catalogues and periodicals were published the works of its membership, which included the likes of Robert Delaunay, Jean Hélion, Wassily Kandinsky, Fernand Léger, El Lissitzky, Kasimir Malevich, Piet Mondrian, Antoine Pevsner, Theo van Doesburg, and Georges Vantongerloo. Interaction among artists helped break down the international distinctions and chauvinism attributed to various movements. French Cubists, Russian Constructivists and Suprematists, German Bauhaus artists, and Dutch Neoplasticists not only exhibited together, but they even drew inspiration from one another.

Although Europeans were the innovators of progressive art, artists from New York gradually became parties to these trends. A number of future AAA members – including Herzl Emanuel, John Ferren, Albert E. Gallatin, Gertrude and Balcomb Greene, Carl Holty, Frederick Kann, George L. K. Morris, Louis Schanker, Charles Shaw, Vaclav Vytlacil, and Jean Xceron – were a part of the international mix in Paris during the 1920s and 1930s. Following a long tradition in American art, members of this younger generation had gone abroad to study art and to expand their artistic experience. Consequently, when they returned to New York, they brought back an enriched knowledge of European modernism and, in many instances, important contacts with major European artists. Several future AAA members were born abroad, and some, such as Werner Drewes and John von Wicht, brought with them to New York the benefits of direct participation in progressive European movements. For Americans who had remained at home, the excitement of Paris could be gleaned through friendships with compatriots who had been abroad, and through such periodicals as *Cahiers d'Art* and *Plastique*.

Among the Americans who made substantial contacts in Paris, Albert E. Gallatin helped to establish early on a tangible foothold for European and American abstraction in New York. A wealthy, well-connected collector and cubist painter, whose tastes had progressed from Aubrey Beardsley and James McNeill Whistler to Cézanne, Léger, Picasso, and beyond, Gallatin in 1927 founded the Gallery of Living Art (renamed the Museum of Living Art in 1931) in a library reading room at New York University in Washington Square.[2] Open during the evening and featuring free admission, his museum became an oasis where artists and the

2
The major study on Gallatin and his museum is the exhibition catalogue by Debra Bricker Balken, *Albert Eugene Gallatin and His Circle* (Coral Gables, Fla.: Lowe Art Museum, University of Miami, 1986).

public could view progressive contemporary art. Gallatin developed his collection as a survey of modern art evolving from the abstraction of Cubism to the nonobjectivism of Constructivism and Neoplasticism. About 1930 he broadened his commitment to include American abstractionists, and he began collecting and exhibiting works by Charles Biederman, Alexander Calder, John Ferren, Alice Trumbull Mason, George L. K. Morris, Charles Shaw, and Esphyr Slobodkina, among others. Gallatin's financial support of some of these Americans proved important to their livelihoods. His embrace of American abstract painters was virtually unique in New York at the time.

In contrast were the exclusionary activities of two potentially much more powerful institutions. Founded in 1929, two years after Gallatin's gallery had opened, the Museum of Modern Art (MoMA) unequivocally reflected a European bias, developing holdings that featured movements from Impressionism to Cubism. Though the American abstractionists might have looked forward to the opening of such a collection in New York, they were soon chagrined to learn that MoMA, through its director Alfred Barr, Jr., politely declined to exhibit their work. Furthermore, it soon became painfully clear that the museum subscribed to the popular notion that the best current American art was not to be found in abstraction or nonobjectivism, but in realism, particularly in the art of the regionalists and the Social Realists.

Barr's attitude was epitomized by the now-famous exhibition *Cubism and Abstract Art,* which he mounted in 1936. With Cubism as its centerpiece, the exhibition explicated in a variety of media the progression in Europe of twentieth-century modernism, including the achievements of Constructivism, Suprematism, the Bauhaus, and Neoplasticism. Barr's exclusion of the very Americans who had mingled with many of these Europeans abroad and had been strongly influenced by them clearly indicated that he did not view American abstraction either as equal in stature to or as part of the international continuum of nonrepresentational art. Barr attempted to justify this omission in his preface to the catalogue, noting that the Whitney Museum of American Art had treated the subject only the year before in its show *Abstract Painting in America.*

Founded in 1930, the Whitney performed only slightly better in the eyes of young American abstractionists. Just as MoMA excluded them in favor of Europeans, the Whitney basically overlooked them for more conservative American schools of realism and modernism. Though dedicated to the art of this country, the Whitney gave priority to realism of the early twentieth century and to the older generation of artists who defined the "first wave of American abstrac-

tion," many of whom Alfred Stieglitz had brought to public attention in the 1910s and 1920s. *Abstract Painting in America* reflected the conservative vision of the Whitney through its emphasis on Stieglitz's circle and its inclusion of realists such as Walt Kuhn and Glen Coleman, who hardly fit within even the broadest definition of abstract art. Though not totally excluded, current abstraction was allotted relatively little space. This kind of harsh treatment, coupled with the fact that few commercial galleries exhibited or promoted contemporary American abstraction, helped fuel discussions among several young vanguard artists about forming a group.

The Federal Art Project of the Works Progress Administration (WPA) unwittingly served in the mid 1930s as the most important catalyst for bringing diverse groups of abstract painters together in New York. Established as part of the New Deal under the Roosevelt administration in 1935, the project remained in place until 1941, though it was most active between 1935 and 1939.[3] Its primary goals — the employment of artists during the Depression and the integration of art into daily American life — were to be achieved through the activities of four sections: Fine Arts, Practical and Applied Arts, Educational Services, and Technical Supervisory Personnel. The most visible and highly publicized was the Fine Arts Division, which included subdivisions for easel painting, sculpture, graphic arts, and murals. It would be difficult to overestimate the impact of the Federal Art Project, which paid a regular salary to thousands of artists working in all manners. Affording a measure of dignity to those who relied on it for their sole income, the project also provided a forum for the exchange of ideas. Many future members of the AAA were employed by the Fine Arts Division and first became acquainted with one another through this association.[4] Many were also members of the Artists' Union, an organization that served as a vehicle through which artists could negotiate with the massive bureaucracy of the WPA about such issues as hourly wages.

Unfortunately for those artists who were committed to abstraction, the WPA administration, the public, and the critics largely viewed regionalism and narrative art as more effective than abstraction in communicating to the masses the cultural ideals of the nation. Consequently, there was often reluctance on the part of WPA supervisors to assign projects to abstract artists. A notable exception, however, was the Mural Division, which was supervised by Burgoyne Diller.[5] A serious and well-respected painter working in a neoplasticist manner, Diller was also an agile mediator between artists and administrators. Given his astute managerial abilities, his selection as supervisor was extremely fortuitous for abstract artists in

3
Among the most comprehensive studies on the WPA Federal Art Project are two works by Francis V. O'Connor, *Federal Support for the Visual Arts: The New Deal and Now* (Greenwich, Conn.: New York Graphic Society, 1969) and *Art for the Millions: Essays from the 1930s by Artists and Administrators of the WPA Federal Art Project* (Greenwich, Conn.: New York Graphic Society, 1973).

4
Among those represented in this exhibition catalogue who participated in the Federal Art Project in New York are Bengelsdorf, Bolotowsky, Browne, Diller, Drewes, Balcomb Greene, Krasner, Lassaw, Pereira, Reinhardt, Schanker, Swinden, and von Wicht.

5
An excellent study on the Mural Division of the WPA Federal Art Project is: Greta Berman, *The Lost Years: Mural Painting in New York City Under the WPA Federal Art Project, 1935–1943* (New York and London: Garland Publishing, 1978).

New York. Because of the public nature of mural art and its novelty as an art form in America, this division garnered the greatest public visibility within the Federal Art Project. Diller enlisted many fellow abstract artists in four extensive projects overseen by his division: at the Williamsburg Housing Project (1937–1938) in Brooklyn; at the radio station WNYC (1939); at the New York World's Fair (1939–1940); and at the Chronic Disease Hospital on Welfare Island (1940–1941). This was a bold move on Diller's part because the ability of the abstract artist to convey in broadly understandable language themes pertinent to the social, economic, and historical values of the nation was constantly under attack. Diller remained undefeated by these popular prejudices and committed to the inherent value of nonrepresentational art, and he recruited the best artists working in various modes of abstraction in New York. Rosalind Bengelsdorf, Ilya Bolotowsky, Harry Bowden, Byron Browne, Balcomb Greene, Hananiah Harari, Lee Krasner, Leo Lances, George McNeil, Louis Schanker, Albert Swinden, and John von Wicht were among those employed by the Mural Division who would later participate in the AAA. This group reflected a rich stylistic diversity that drew on Cubism, the Surrealism of Arp and Miró, Neoplasticism, Constructivism, and Bauhaus geometry.

While the debate between realism and abstraction was being waged in public arenas, such as museums and the Federal Art Project, it was also being carried out in other corners of New York, including the Art Students League, one of the foremost art schools in the city. Throughout much of the 1920s the faculty of the league had been dominated by committed realists, including Thomas Hart Benton, Reginald Marsh, Kenneth Hayes Miller, and John Sloan. In the late 1920s and early 1930s the introduction of an international viewpoint on abstraction through the teaching of artists such as Jan Matulka, Vaclav Vytlacil, and his mentor, Hans Hofmann, caused considerable consternation among realists on the faculty. Hofmann, a German-born painter thoroughly entrenched in the development of European modernism, had fled his native land for the United States. He brought a dynamic approach to the teaching of formalist principles of color, form, and space in abstraction. Though he left the Art Students League within a year of his appointment in 1932 and established his own school, Hofmann became one of the most important teachers of young abstract painters. More than half of the founding members of the AAA numbered among his loyal students, and although he never joined the group, he wholeheartedly supported its formation.

In 1935 and 1936, as the lines were drawn in New York between the virtues of realism and abstraction and between the merits of European and American abstraction, American

abstractionists began gathering to discuss the formation of an independent organization to bolster their status. Though the chronology of these early meetings remains vague (even among those who attended them), it is clear that by January 1936 discussions were underway among Rosalind Bengelsdorf, Byron Browne, Gertrude and Balcomb Greene, Burgoyne Diller, Harry Holtzman, Ibram Lassaw, and Albert Swinden. The gaining of visibility through the mounting of exhibitions was a primary topic, and the group approached John I. H. Baur of the Brooklyn Museum about doing so. A decade before, this institution had sponsored an important exhibition of Katherine Dreier's collection of European modernism, which had been assembled under the aegis of the Société Anonyme, an organization Dreier had founded with Marcel Duchamp in 1920 for the purpose of promoting progressive art. However, Baur declined the request of these young Americans.

During 1936, critical discussions were held to thrash out the main purpose of the proposed organization. By late in the year, more than thirty artists were attending these meetings, and several different proposals were brought forth. Holtzman, Arshile Gorky, and a few others envisioned the new organization as a setting for the debate of aesthetic and philosophical issues, and even for the critique of fellow members' work. The majority, however, saw a more pragmatic function, which became the basis of the "General Purpose of the Constitution of the AAA," drafted shortly thereafter:

> The purpose . . . is to unite American "abstract" artists (1) to bring before the public their individual works, (2) to foster public appreciation of this direction in painting and sculpture, [and] (3) to afford each artist an opportunity for developing his own work by becoming familiar with the efforts of others, by recognizing differences as well as those elements he may have in common with them.[6]

The constitution also addressed the choice of the word *abstract* to describe the character of the group. Recognizing that it was not an adequate or even an accurate term, the members invited a liberal interpretation, allowing for "the need for individuals to experiment and deviate at times from what may seem established directions."[7] Finally, the document outlined the programs of the AAA, giving annual group exhibitions of members' work the highest priority, after which came group discussions and educational promotion of their art and activities through books and pamphlets. The goal of reaching and educating the public reflected a philosophy many members carried with them from their experience at the Federal Art Project.

Almost immediately, the AAA began to carry out its mission. By April 1937 the group had mounted its first show at galleries in the Squibb Building on Fifth Avenue. It was the most signifi-

6
Quoted from Susan C. Larsen, "The American Abstract Artists Group: A History and Evaluation of Its Impact upon American Art" (Ph.D. diss., Evanston, Ill.: Northwestern University, 1975; reprinted in Ann Arbor, Mich.: University Microfilms International), pt. 2, p. 478.
7
Ibid.

cant exhibition of contemporary American abstract art to that date. Unlike the Whitney show of 1935, the inaugural exhibition of the AAA was composed completely of current abstract and nonobjective work, with thirty-nine members contributing two or three works each. More than fifteen hundred visitors attended the two-week venue, but very few works were sold and reviews were mixed. Many described the work as too rarefied and decorative. Though critics used the terms *eclectic* and *derivative* in noting that the Americans relied too heavily upon European precedents, the AAA members themselves fully accepted these influences as important, and they looked at their own achievements not from a nationalist viewpoint, but rather as part of an evolving international phenomenon.[8] Many reviewers selectively acknowledged admiration for individual works, and Charmion von Wiegand, who would later join the AAA herself, wrote most positively about the new vitality this group of young, capable artists had brought forth.

On the whole, the group was not surprised or defeated by the response. It gained new members from the publicity, and the following fall organized a second show at Columbia University. In 1938, the second annual exhibition garnered an attendance of more than seven thousand, and it was accompanied by an eighty-page yearbook featuring articles by nine members and illustrations of work by nearly all forty-eight members. The same year, the AAA expanded its audiences by circulating a small show to Seattle, San Francisco, Kansas City, and Milwaukee.

The level of activity of the organization remained relatively high during the next couple of years, despite the fact that many members were, for financial reasons, putting most of their energies into assignments at the Federal Art Project. Nevertheless, in 1939 the AAA produced its second yearbook — listing fifty-three members — to accompany its third annual. The following year, six members were included in the show *American Art Today* at the New York World's Fair, where several others were represented by murals. In 1940 and 1941 the names of European artists immigrating to New York — most notably Léger, László Moholy-Nagy, and Mondrian — were incorporated on the exhibition roster, adding credibility to the organization, which, in turn, acknowledged the influence of these masters.

Among the most radical of the group's public activities was a sidewalk protest of MoMA on April 15, 1940. This demonstration, attended by a large majority of members, reflected their increasing frustration with the exhibition policies of the museum. MoMA continued to decline requests to exhibit the work of these young artists and raised their fury further by presenting

8
Ibid., pp. 253–60, and the exhibition catalogue by Thomas Tritschler, *American Abstract Artists* (Albuquerque: University Art Museum, University of New Mexico, 1977), pp. 19– 20.

a skewed picture of contemporary art. The 1939 exhibition *Art in Our Time* at MoMA had demonstrated a lopsided equation in juxtaposing the work of Léger, Mondrian, Picasso, and other European moderns with paintings by American realists Thomas Eakins, Winslow Homer, John LaFarge, and James McNeill Whistler, the latter group having all been dead for twenty years or more. The final straw for the AAA was a show at MoMA of cartoons from the tabloid *PM,* a subject many felt was particularly trivial in view of the fact that the museum had indicated its schedule was too full to accommodate an exhibition of work by AAA members. As a result, the young abstractionists turned out in force to picket and to distribute to passersby a broadside that graphically and sarcastically summarized their points of disagreement with the museum. Unfortunately, the protest gained them little in the way of tangible results, and a few members – Ferren, Gallatin, Morris, and Shaw – objected to its radical, disjointed nature.

It is not surprising, given the remarkable diversity of individuals and styles within the AAA, that dissension within the organization slowly began to erode its cohesiveness during the early 1940s. Some division arose over stylistic differences, with one segment aggressively promoting geometric abstraction, while other members preferred to explore expressionistic manners or even approaches more firmly rooted in the physical world. Political differences also caused disruption, as some artists became increasingly disillusioned with the Marxist politics they had once supported. World War II also took its toll on members of the AAA; some were called away to military service, and others were engaged in war-related efforts. By 1940 the impact of the Federal Art Project had waned significantly, as government funds were diverted to other priorities, including the war. By 1942 several members had resigned from the AAA because they felt the group had achieved much of its mission in securing attention for American abstraction.

Unquestionably, the New York art scene had begun to change, and in some ways it indeed appeared more receptive to contemporary American abstraction. In the late 1930s, the Solomon R. Guggenheim Foundation opened the Museum of Non-objective Painting under the directorship of Hilla Rebay. This museum was one of the few to mount exhibitions of American nonobjective art in New York during this time. With collections strongly focused on the work of Rudolf Bauer, Kandinsky, Klee, and Moholy-Nagy, the museum reflected an alternative vision to both Gallatin's cubist-oriented holdings and the more historical survey of MoMA. Rebay's interest in theosophy and in the spiritual or transcendental potential of art was reflected in the artists she chose to support through the museum. Although her viewpoint was not shared by the majority of AAA members, who had openly rejected her dogmatic stance on spirituality,

by 1942 several members were represented in the collection of the Museum of Non-objective Painting, including Bolotowsky, Ferren, Balcomb Greene, Lassaw, Pereira, Sennhauser, Shaw, Slobodkina, Swinden, and Xceron; Pereira, Sennhauser, and Xceron also served on the staff of the museum.[9]

The change in the artistic temperament of the city continued as the war brought to New York a group of European artists and writers other than the mentors whom many AAA members had found in Abstraction-Création. Centered on a more psychologically based form of Surrealism, André Breton, Max Ernst, André Masson, Roberto Matta, Yves Tanguy, and others soon added to the texture of the New York art scene, and assisted in directing abstraction away from the pure formal and geometric styles associated with the AAA and toward the expressionist and the unconscious. This new mythic art beckoned another coterie of Americans which included William Baziotes, David Hare, Robert Motherwell, Jackson Pollock, and Clyfford Still, and ultimately led to the rise of Abstract Expressionism in the late 1940s. Commercial galleries and dealers began to take an active interest in these European and American Surrealists.

Another symbol of the change in the New York art world was the decision by Gallatin to close the Museum of Living Art in 1943. Faced suddenly with having to find new quarters, Gallatin refused a surprising overture from Alfred Barr to house his collection at MoMA. Remembering rebuffs of the AAA by MoMA, Gallatin instead gave most of his collection to the Philadelphia Museum of Art.

The end of World War II, the discontinuance of the WPA, the rise of Abstract Expressionism, and the growing tolerance of nonrepresentational art all signaled a new era for the AAA. Though the organization remains a viable group even today, the heyday of its activist energy had subsided by the mid 1940s. A transition in membership occurred during the next several years, with many original members resigning and younger artists joining. As the AAA has reached maturity in a more accepting environment, it has shed its earlier reputation as a struggling radical group.

However, the legacy of its activist years cannot be overestimated. Though the majority of the original members never received the international recognition their successors did, their protest for recognition of the American avant-garde helped pave the way for subsequent waves of abstraction. And though its art was declared eclectic and derivative by many critics and museums, the AAA was truly distinct from its European counterparts in its democratic

9
Susan C. Larsen, "The Quest for an American Abstract Tradition, 1927–1944," in *Lane and Larsen,* p. 41.

stance: its membership cut across many socioeconomic boundaries to include almost all major artists working in abstraction who wished to join. The AAA avoided elitism both in its effort to reach a diverse audience and in its belief that the public could appreciate nonrepresentational art. Out of its diversity, the organization found a purpose and a strength in the struggle to carry forward the continuum of a socially relevant avant-garde.

ROSALIND BENGELSDORF (1916 – 1979)

1

Study for Mural

(for Central Nurses Home
on Welfare Island), 1937
casein and graphite
on paper
4¹¹/₁₆ × 13¹/₁₆ in.
(12 × 33.2 cm)
inscribed in graphite on
reverse: *Preliminary sketch
for Mural for Central
Nurses Home, Welfare
Island/Scale
1¼" = 1'/by Rosalind
Bengelsdorf*

2

Study for Oil, about 1938
gouache and graphite
on paper
5¼ × 7¼ in.
(13.4 × 18.5 cm)

Although Rosalind Bengelsdorf was one of the youngest members of the AAA, she helped found the organization and later became one of its important chroniclers. She enrolled in the Art Students League between 1930 and 1934. There she studied with George Bridgman the reduction of objects to fundamental geometric volumes which started her on a path toward abstraction.[1] In 1935 she attended on scholarship Hans Hofmann's art classes at his Fifty-seventh Street studio, where she became acquainted with his famous "push-pull" theory. This focused on the interaction of all forms on the canvas, the role of negative and positive shapes, and the forward-backward movements created by color. In 1940 Bengelsdorf married the artist Byron Browne and willingly ceased painting in order to become a full-time wife and mother. However, she continued to participate in the art world, beginning a career in 1947 as a critic and columnist. After her husband's death in 1961, she resumed painting and began to teach.

Bengelsdorf believed in the interdependence of all visible and invisible matter. She painted not only what she saw in nature, but also what she knew of the natural internal function of each object — the tension, opposition, and interrelation of planes in space. In *Study for Oil* and *Study for Mural* Bengelsdorf utilized the lessons of both Bridgman and Hofmann: she reduced all objects and their surrounding space to basic geometric forms and left the location of the multiple opaque planes ambiguous, relying primarily on unmodulated areas of color to recede or advance in space.

In 1936 Bengelsdorf joined the abstract artists working under the WPA, participating first in the Teaching Division and later in the Mural Division under the leadership of Burgoyne Diller. Along with Hananiah Harari, Bengelsdorf was commissioned to create a work for the living room of the Central Nurses Home on Welfare Island. Various mural projects were being worked on about the same time by other abstract artists for the Chronic Disease Hospital on Welfare Island.

One of a number of existing works that have been identified as studies for the mural at the Central Nurses Home, Bengelsdorf's sketch was based on a musical motif and was gridded for transfer to a larger scale.[2] She paired biomorphic shapes evocative of guitar bodies with hard-edged geometric elements that appear to be sections of stringed instruments. Abstracted from identifiable objects, these forms comprise a conceptual, rather than naturalistic, representation. Bengelsdorf found that her work became more understandable and acceptable to a broader public when she included such representational imagery. The completed composition was a small, portable mural measuring approximately two by five feet. Unfortunately, most of the murals on Welfare Island were damaged within a few years and then covered by successive layers of wall paint.

The motif in *Study for Oil* is less apparent than that in *Study for Mural,* though the former may represent an interior with a still life in the center and a sunlit window to the right. In 1938 it was developed into an untitled oil painting measuring twenty-four by thirty-six inches.[3]

Notes

1 Learning how to draw the solid, geometric structure of visible objects helped her imagine and depict connecting areas of space in her later cubist-inspired abstractions.

2 Sketches for the mural are located at the National Museum of American Art, Washington, D.C.; the University Art Museum, University of New Mexico, Albuquerque; the Whitney Museum of American Art, New York; and the Washburn Gallery, New York. Although the sketches are stylistically and coloristically compatible with one another, they vary significantly in motif and scale. Furthermore, it is not clear how the sketches relate to one other chronologically because the final version is unknown. According to Bengelsdorf's son, Stephen B. Browne, the artist noted that the sketches from the Yasuna Collection and the Whitney are quite different from the completed version; letter from Stephen B. Browne to Elaine D. Gustafson, Jan. 2, 1991.

3 Letter from Stephen B. Browne to Elaine D. Gustafson, Jan. 2, 1991. The location of the finished painting is currently unknown to this author.

Selected References

Larsen, Susan C. "An Interview with Mrs. Rosalind Bengelsdorf Browne," in "The American Abstract Artists Group: A History and Evaluation of Its Impact Upon American Art" (Ph.D. diss.), pp. 539–59. Evanston, Ill.: Northwestern University, 1975.

Mecklenburg. *Frost Collection,* pp. 32–35.

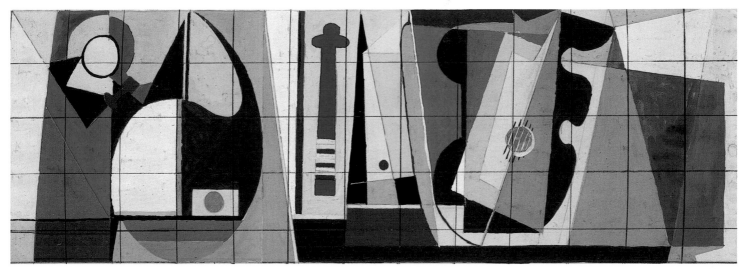

1

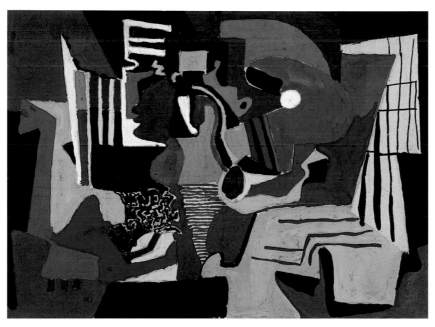

2

ILYA BOLOTOWSKY (1907 – 1981)

3

Biomorphic Constructivist Composition, about 1935

oil and graphite on paper

$11^{11}/_{16} \times 13^{13}/_{16}$ in.

(29.7 × 35.2 cm)

inscribed in graphite on reverse: *IB-OP-4*

A founding member of and active participant in the AAA, Ilya Bolotowsky became interested in non-objective painting in the early 1930s. Born in Russia but trained at the National Academy of Design in New York from 1924 to 1930, he was influenced by several European movements, although he is perhaps best known for his neoplasticist work dating from the 1940s to his death. In 1932 a trip to Europe, where he studied Parisian and Russian painting, made him receptive to such avant-garde styles as Cubism, Constructivism, Suprematism, and the biomorphism of Jean Arp and Joan Miró. By the mid 1930s, when Bolotowsky was employed by the WPA Federal Art Project to paint abstract murals, his style had already progressed from expressionist and cubist-inspired paintings in which he abstracted nature to nonobjective paintings composed of both geometric and biomorphic forms.[1] This evolution in his style occurred in 1933, the year he first saw paintings by Miró and Piet Mondrian. In his search for his own style, Bolotowsky temporarily combined the two vocabularies into a single idiom. Bolotowsky married in 1933 his first wife, Esphyr Slobodkina, an artist who was strongly influenced by her husband's work.

Biomorphic Constructivist Composition appears, in its cursory execution, to be a study.[2] Biomorphic, cubist, and geometric shapes superimposed upon one another playfully interact in an open, undefined field of space. The organic shapes, which evoke associations with bodily appendages such as fingers, arms, legs, and heads, derive from Miró's anthropomorphism, but the flattened volumes and the interweaving of figural forms and background within a shallow space are lingering influences from cubist collages. The introduction of generally rectilinear shapes suggests an appreciation of Russian Constructivism and a tentative exploration of Mondrian's grids; Bolotowsky's geometric forms, however, are not as rigidly defined and situated in space as those of Mondrian.

In 1940, Bolotowsky purged the organic and cubist forms from his canvases in favor of the hard-edged, rectilinear abstractions of Neoplasticism. By this time, his friends Burgoyne Diller and Albert Swinden were already working in this idiom and, like them, he was attracted to the order, restraint, and clarity of the movement. However, Bolotowsky created his own variant of Neoplasticism by

expanding his palette beyond the primary colors and increasing the variety and types of linear relationships, thus effecting the sense of movement.[3] He also began to use shaped canvases, favoring the diamond, the tondo, and the ellipse, and in 1961 and 1962 he expanded further upon neoplasticist principles by creating three-dimensional painted columns.

Notes

1 Burgoyne Diller arranged for Bolotowsky to transfer from the Teaching Division to the Mural Division of the Federal Art Project.

2 A graphite drawing for another, stylistically similar composition appears on the reverse of this oil sketch.

3 His use of diagonals in works dating from the 1940s indicates a continued suprematist influence, one that he eventually eliminated in order to achieve flatness.

Selected References

Larsen, Susan Carol. "Going Abstract in the '30s," *Art in America,* vol. 64 (Sept.–Oct. 1976), pp. 71–79.

*Svendsen, Louise Averill; and Mimi Poser. "Interview with Ilya Bolotowsky," in *Ilya Bolotowsky* (exh. cat.). New York: The Solomon R. Guggenheim Museum, 1974.

Troy, Nancy J. *Mondrian and Neoplasticism in America* (exh. cat.). New Haven: Yale University Art Gallery, 1979.

3

HARRY BOWDEN (1907 – 1965)

4

Untitled Abstraction,

about 1936–1939

gouache and graphite

on paper

11⅛ × 9¹⁄₁₆ in.

(28.3 × 23 cm)

inscribed in graphite

on reverse: *#2*

Perhaps better known for his successful photographs – commercial and fashion portraits and sensual female nudes – Bowden began studying art in 1927 in his native city at the Los Angeles Art Institute, later producing a commercial motion picture and working as an advertising designer. Between 1928 and 1931 he attended the National Academy of Design and the Art Students League in New York, and the Chouinard School of Art in Los Angeles, but he soon became disenchanted with formal academic classes. He decided to engage seriously in painting in 1931 after attending an eye-opening summer class taught by the charismatic Hans Hofmann at the University of California at Berkeley. Bowden studied with Hofmann again in 1934 in New York and became one of his studio assistants the next year. Bowden was one of the founding members of the AAA, and he counted George McNeil, Ad Reinhardt, Albert Swinden, and Wilfred Zogbaum among his friends. In 1937 and 1938 Bowden painted two murals for the Williamsburg Housing Project under the auspices of the WPA Federal Art Project. Although Bowden returned to California in 1942 and became a shipfitter, he continued to show his work in New York, a city he visited periodically.

Bowden's emerging style prior to 1940 was predominantly influenced by his association with Hofmann, in tandem with an interest in Cubism and an admiration for Matisse.[1] Working both figuratively and abstractly, Bowden found greater challenge and possibility – as had Hofmann – in an abstract style based upon motifs of nature than in either traditional representation or pure nonobjectivity. In *Untitled Abstraction,* Bowden applied the decorative colors, sense of pattern, and surface enrichment of Matisse to a compositional arrangement based on Cubism. The artist abstracted the objects to the degree that they are no longer recognizable, but they approximate a typical cubist table-top still life in terms of their compositional arrange-

ment. The fluid shape in the foreground and the gestural brushwork invigorate the static, traditional cubist design.

Although photography began to take on a greater role in Bowden's life after World War II, he continued to paint loose, gestural paintings that show an affinity with Cézanne's mature works. From the mid 1950s until his death in 1965, Bowden concentrated mainly on the figure, both in his paintings and in his photographs.

Note

1 Bowden painted a picture in 1938 entitled *After Matisse.*

Selected References

Heyman, Therese Thau; and Terry St. John. *Harry Bowden: Artist Out of the Mainstream* (exh. cat.). Oakland, Calif.: Oakland Museum of Art, 1979.
Mecklenburg. *Frost Collection,* pp. 41–43.

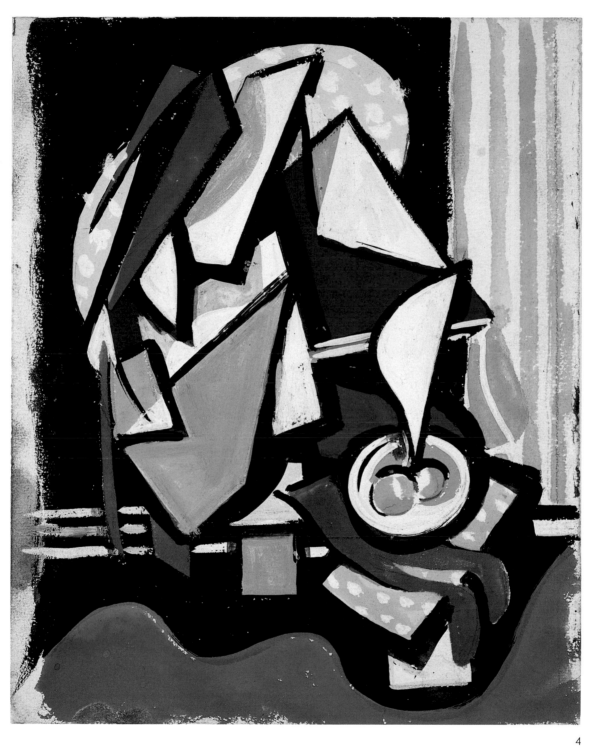

5

Mayan Head, 1940

ink, watercolor, and

graphite on paper

13^{15}⁄$_{16}$ × 11 in.

(35.4 × 28 cm)

signed and dated in ink

at lower right: *Byron*

Browne 1940

inscribed in graphite

on reverse: *BB10/*

MAYAN HEAD

stamped on reverse: *The*

Pinacotheca/20 West 58

Street/New York City, NY/

Estate of/Byron/Browne

6

Woman of War, 1942

red and black ink,

watercolor, and graphite

on paper

13^{15}⁄$_{16}$ × 11 in.

(35.4 × 28 cm)

signed and dated in ink

at lower center: *Byron*

Browne/1942

inscribed in graphite on

reverse: *Woman of War*

stamped on reverse:

Estate of/Byron Browne

Open-minded toward all forms of artistic expression, Byron Browne was active organizationally and politically in establishing abstraction as a valid means of expression in American art. He was a member of the American Artists' Congress and the Artists' Union, and a founding member of the AAA and of the Federation of Modern Painters and Sculptors, whose interests lay in aesthetic values rather than in the political and economic concerns of the Artists' Congress. Browne exhibited with the AAA from 1937 to 1946 and again from 1954 until his death in 1961. Like many of his contemporaries, including his wife, Rosalind Bengelsdorf, he also worked for the Mural Division of the WPA Federal Art Project.

From 1924 to 1928, Browne pursued a traditional course of study at the National Academy of Design in New York City; there, his talents were recognized early. However, his interests in representational art shifted, and he soon rejected academicism.[1] While still a student at the academy, he had encountered the Cubism of Braque and Picasso at Gallatin's newly opened Gallery of Living Art, and, consequently, he began to experiment with abstract forms. As early as 1929, cubist-inspired paintings, drawings, and sculpted heads appeared in Browne's oeuvre. Issues of the French periodical *Cahiers d'Art* brought him an expanded view of progressive European art. Furthermore, in 1935 he studied with the dynamic teacher Hans Hofmann, who remained a lifelong friend and an important influence.

Although specific imagery found in nature was always the starting point for Browne's compositions, he moved away from traditional naturalism during the early 1930s by exploring cubist fragmentation of form. However, these early experimentations with Cubism were supplanted in the late 1930s and early 1940s by his knowledge and appreciation of the looser, biomorphic forms of Jean Arp and Joan Miró. During this period Browne combined in varying degrees and styles geometric and organic shapes, believing he did not need to choose one style over another.

From the late 1930s to the mid 1950s Browne found inspiration in the large, simple, and stylized shapes of mythic, classical, and primitive art.[2] Colorful, flamelike, intricate paintings such as *Mayan Head* and *Woman of War* reflect elements of universal symbolism that the artist found in such primitive art sources as Catalonian murals; Sumerian, Chaldean, and Assyrian figures; and Precolumbian motifs. The type, androgyny, and depiction of the warriors in these two images – massive lines of hair and open mouth – are characteristic of Mayan motifs, which were of particular interest to Browne in the late 1930s and early 1940s. Browne included certain key motifs, such as the heavily ringed eye and the dotted "tongue," which is a Native South American symbol for corn (fertility), that had become part of his personal iconography.

During the fifties Browne's work became increasingly more painterly and expressionistic, paralleling the growth of Abstract Expressionism and its incorporation of abstract symbols. However, throughout his career Browne continued simultaneously to produce work reflecting various degrees of abstraction.

Notes

1 Browne destroyed his early academic work, but remained committed to the value of tradition as a solid artistic footing.

2 His interest in mythology and classicism was enhanced by his job during the 1940s as a guard in the Greek and Roman section at the Metropolitan Museum of Art, New York. His depictions of classical figures also indicate a study of Ingres and Picasso.

Selected References

*Berman, Greta. "Byron Browne: Builder of American Art," *Arts Magazine,* vol. 53, no. 4 (Dec. 1978), pp. 98–102.

*Paul, April J. "Byron Browne in the Thirties: The Battle for Abstract Art," *Archives of American Art Journal,* vol. 19, no. 4 (1979), pp. 9–24.

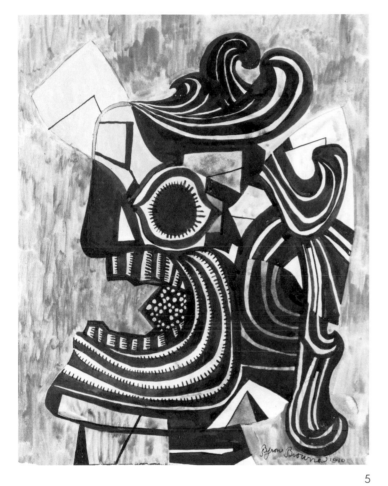

5

6

7

Untitled, No. 536,

about 1938–1939

watercolor and graphite

on paper

5 × 4⅛ in.

(12.6 × 10.4 cm)

inscribed in graphite on

reverse: *R172-81/#536*

blind stamped at lower

right: *Estate of/Burgoyne*

Diller

8

Second Theme, No. 580,

about 1938–1939

watercolor and graphite

on paper

5 × 4⅛ in.

(12.6 × 10.4 cm)

inscribed in graphite on

reverse: *#580/R93-81*

blind stamped at lower

right: *Estate of/Burgoyne*

Diller

It is perhaps ironic that, although Burgoyne Diller played a crucial role in supporting and promoting abstract art in the 1930s and 1940s, his association with the AAA was sporadic. As director of the Mural Division of the WPA Federal Art Project, Diller became acquainted with nearly every abstract artist working in New York City; however, he had to sacrifice time in his studio in order to fulfill the demands and responsibilities of this important position. Not only did this affect how much work he produced, but it may also have been the reason he was neither a founder of the AAA nor among the artists immediately invited to join. Eventually, he did join the group, but he participated in only one exhibition between 1937 and 1941, when he left the organization; he rejoined in 1947.[1]

Diller's formal artistic training began at the Art Students League, where he studied between 1928 and 1933 with Jan Matulka and Hans Hofmann. Hofmann, in particular, exerted a lasting influence on Diller, having encouraged the younger artist to experiment with spatial elements such as the "push-pull" effect produced by the play between forms and colors. During this developmental stage, Diller's work reflected a variety of stylistic influences, including Analytical and Synthetic Cubism, German Expressionism, biomorphism, and the Bauhaus aesthetic of Kandinsky. About 1933, after Diller saw the work of Mondrian (probably at Gallatin's Museum of Living Art), he moved toward a more personal style that had its roots in Russian Constructivism and Neoplasticism.[2]

Although Diller adhered to the basic vocabulary of Neoplasticism, with its emphasis on primary colors and black and white on a gridlike rectilinear arrangement, he transformed these essential elements into a personal language, emphasizing spatial recession and overlapping planes. In *Untitled, No. 536* and *Second Theme, No. 580* he did not lock the rectilinear compositions onto the picture plane with a strict, two-dimensional grid in the neoplasticist manner. Rather, by breaking the continuity of the grid, Diller allowed rectangles of color to float in an undefined space: cool colors such as blue and green recede while warm colors such as red, yellow, and orange advance, creating a spatial dynamism that falls outside the neoplasticist idiom. He also experimented with the position, shape, size, and

intensity of colors in order to enhance the rhythms and patterns of the compositions.[3]

After the war, Diller continued to experiment with the principles of Neoplasticism, and he classified his oeuvre in terms of three interrelated visual themes, which he explored simultaneously. These themes were distinguished by the manner in which and degree to which the formal elements – rectangles, squares, or grid lines – were arranged on the picture plane.[4] Works later in date than *Untitled, No. 536* and *Second Theme, No. 580* show an increased overlapping of linear elements of varying intensity of color and thickness. However, toward the end of his career, the artist simplified the format of his compositions, frequently using fewer elements and more subdued rhythms. Not until the 1960s and 1970s, when Diller's hard-edged, geometric idiom attracted the attention of minimalist artists, did his work receive substantial attention.

Notes

1 Haskell, p. 77.

2 Diller had minimal personal contact with Mondrian while he was in New York. They participated together in one exhibition in 1942 and spoke only once (Haskell, p. 83). However, Diller would have seen Mondrian's work in several other exhibitions held in New York.

3 Throughout his career Diller relied on drawings to work out his ideas and to plan compositions. However, it is not known whether these drawings were working studies for larger compositions.

4 Troy, in *Lane and Larsen*, p. 72.

Selected References

*Haskell, Barbara. *Burgoyne Diller* (exh. cat.). New York: Whitney Museum of American Art, 1990.

Troy, Nancy J. "Burgoyne Diller," in *Lane and Larsen*, pp. 70–73.

———. *Mondrian and Neoplasticism in America* (exh. cat.). New Haven: Yale University Art Gallery, 1979.

7

WERNER DREWES (1899 – 1985)

9

Detonation, 1943

oil on canvas

41 × 36 in.

(104.1 × 91.4 cm)

signed at lower left:

Drewes

inscribed at lower right:

4[monogram]3

inscribed on reverse:

305/43

inscribed on stretcher:

DREWES

Throughout the fifty years of his American career, Werner Drewes maintained a consistent, moderate voice of Teutonic abstraction. Trained in the intellectual severity of the Bauhaus, the painter was also influenced by German Expressionism through his explorations as a woodcut artist and through contact with such artists as Max Beckmann. The second child of a Lutheran minister, Drewes was born in the village of Canig, in eastern Germany. Although he received his first art instruction as a child, he began more formal training in architecture and design in Stuttgart following his service in World War I. In 1921 and 1922 he studied at the Bauhaus at Weimar, where he was a pupil of Johannes Itten, Paul Klee, and Oskar Schlemmer. In 1923, Drewes set off on his *Wanderjahr,* hiking through Italy and Spain to see the work of the old masters. He was married in Italy, and he and his wife continued to travel in Europe and then in South and Central America. In 1926 they traveled across the United States, and then visited Japan, Korea, Manchuria, and Russia, before finally returning to Berlin.

Drewes continued his studies at the Bauhaus — then at Dessau — as a student of Klee and Schlemmer, also attending Hinnerk Scheper's mural tutorials and Wassily Kandinsky's private painting classes. Among Drewes's student friends were Lyonel Feininger and László Moholy-Nagy. From that point and throughout his career, Drewes worked simultaneously in abstract and representational styles, one moderating the other. In 1930 he moved with his family to New York, where he continued his active career, striving to exhibit his work widely. In 1931 Kandinsky introduced Drewes to Katherine Dreier, cofounder of the Société Anonyme, thus providing the artist with his first of several exhibitions with this organization. From 1934 to 1936 Drewes taught drawing and printmaking at the Brooklyn Museum School. In 1937 he became an American citizen, joined the American Artists' Congress, and became a founding member of the AAA. He served as director of the WPA Graphic Arts Division in New York City in 1940 and 1941.

The influence of Kandinsky is apparent in the dynamic canvas *Detonation,* in which Drewes manipulated figure and ground in order to achieve intriguing effects of superimposition and transparency. Forms both geometric and organic seem to hover in layers before a smoky ground. Somber colors create a severe mood in this kaleidoscopic composition. Painterly mottling of these dull hues results in a clouded background, which changes nearest the forms, producing effects of shadows and halos and the sensation of space projecting limitlessly in all directions beyond the confines of the frame. These effects are enhanced by the radiating parallel forms that reach beyond the edge of the composition. The artist utilized a common cubist conceit by superimposing shapes and fragmented parallel forms, achieving visual flip-flops that read alternately as superimposed transparent and solid forms. He manipulated and juxtaposed surface effects to support this ambiguity. Sometimes Drewes applied the oil paint in thick impasto, and in other passages he scraped it away. He also used glazes thin enough to reveal underdrawing.

In 1944 Drewes became a member of Stanley William Hayter's Atelier 17, where he produced experimental intaglio prints. He taught design and printmaking at Brooklyn College, and in the summer of 1945 he was an instructor at the Institute of Design, also known as the "New Bauhaus," in Chicago. From 1946 to 1965 the artist taught at the School of Fine Arts of Washington University in Saint Louis. Drewes also maintained an energetic schedule of printmaking, painting, and exhibitions from the 1950s through the 1970s, and his output was prodigious.

DA

Selected References

Frost, Rosamund. "Nature and Abstract," *Art News,* vol. 44 (Feb. 15, 1945), p. 25.

Norelli, Martina Roudabush. *Werner Drewes, Sixty-five Years of Printmaking* (exh. cat.). Washington, D.C.: National Museum of American Art, 1984.

*Rose, Ingrid. *Werner Drewes, A Catalogue Raisonné.* Munich and New York: Verlag Kunstgalerie Esslinger, 1984.

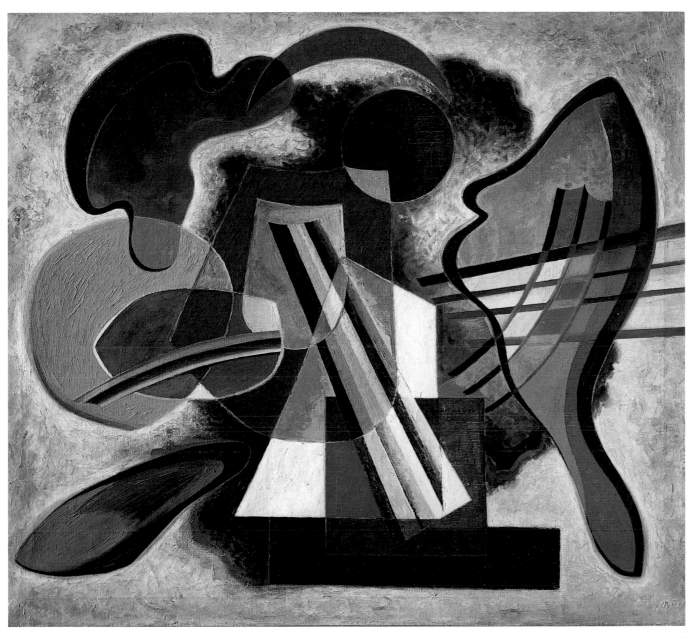

10

Intimacy, about 1936/1979

bronze

11 1/16 × 7 7/8 in.

(28.1 × 20 cm)

incised at base:

Emanuel 3/6 3/8

stamped at base: *RA*

Drawing inspiration from art both of the past and of his own time, Herzl Emanuel consistently depicts elements of the human condition in his sculpture. During his teens, he studied at the Memorial Art Gallery in Rochester, New York. In 1931, with the support of several enthusiastic patrons, he went to Paris, hoping to study with the sculptor Émile-Antoine Bourdelle. However, because Bourdelle died shortly before Emanuel's arrival, the young artist studied instead with Charles Despiau, Fernand Léger, André Lhote, Robert Wlerick, and Ossip Zadkine. In Paris, Emanuel and his friend the American painter Hananiah Harari were attracted to but confused by modern art. In an effort to understand the foundation of modernism's vocabulary and structure, both artists began systematically to draw the collection of the Louvre, beginning with works of ancient cultures and progressing through those of the nineteenth century.[1]

In 1936, following a year or more in Palestine, Emanuel returned to New York and joined the Sculpture Division of the Federal Art Project. Unfortunately, most of the sculpture he produced during the next four years under the WPA was destroyed when the project came to an end.[2] During the late 1930s Emanuel exhibited with various groups, including the AAA, of which he was a founding member. During the war he worked at a shipyard, and afterward he did illustrations.

As a sculptor, Emanuel has used both carved and cast techniques, and he has drawn upon the wide range of stylistic sources he first encountered in Paris. Regardless of the medium or style, a deeply felt humanism always pervades his sculpture, and he has consistently sought to achieve in his work a fusion of abstract form with emotional content.

Emanuel created the plaster for *Intimacy* in 1936, while he was employed by the WPA.[3] Suggesting a human embrace, the faceted composition clearly reflects Emanuel's exploration of various modernist styles, especially Analytical Cubism. In his effort to create a dynamic image of two figures combined into one, the artist, as he himself has explained, reduced "their natural forms into their various geometric components and recombined them arbitrarily to produce the desired effects."[4] The elaborate interplay of convex and concave forms within a highly abstracted figurative theme points most directly to the influence of the Russian-born cubist

sculptor Ossip Zadkine, with whom Emanuel had studied in 1934. A sense of rotational movement, which is heightened by the curvilinear profiles of voids and masses, also suggests Emanuel's awareness of the futurist sculpture of Umberto Boccioni. Whatever the specific influences he felt, Emanuel recently wrote with poignancy of his attitude toward the expressive power of abstraction: "The years of the '30s combined the harrowing experience of the Great Depression with the rise of Fascism and the growing threat of war. These events profoundly affected the world of the artists and found expression in much of their work ... including some of the artists who work in the abstract idiom."[5] A turning point came when Emanuel saw Picasso's enormous painting *Guernica,* which demonstrated for him "how the language of Cubism could be bent to the uses of highly charged human subject matter."[6]

Between about 1930 and 1970 Emanuel's sculpture evolved more drastically in style than in theme, progressing from an analytical cubist manner to an expressionist one. Emanuel diverged gradually from the pure, geometric abstraction favored by many AAA members, and, as a result, he withdrew from the group. During the late 1950s he taught illustration, sculpture, and a foundations course at the School of Visual Arts in New York. He left that teaching position in 1962 and moved to Rome, where he set up a sculpture studio and foundry. In that city, he also taught at Loyola University and at the American College of Rome. He returned to the United States in 1984.

Notes

1 Mecklenburg, *Frost Collection,* p. 60.

2 Inconceivable as it may seem, many of Emanuel's works, as well as sculpture by other WPA artists, were dumped into the East River for disposal.

3 The bronze in the Yasuna Collection was cast, with the permission of the sculptor, from the plaster of 1936 by the New York dealer Martin Diamond in 1979; at that time six bronzes were cast out of the total possible edition of eight.

4 Letter from Herzl Emanuel to Elaine D. Gustafson, Mar. 21, 1991.

5 Ibid.

6 Ibid.

Selected References

Herzl Emanuel: Sculptures and Drawings 1962–1983 (exh. cat.). Miami Beach: Bass Museum of Art, 1983.

*Mecklenburg. *Frost Collection,* pp. 60–63.

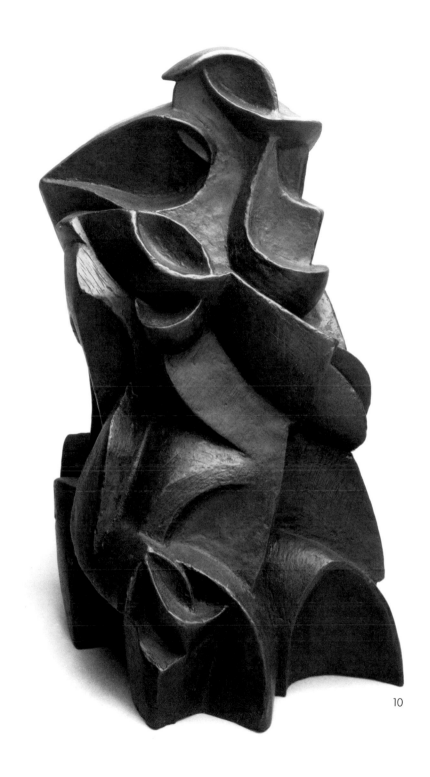

10

JOHN FERREN (1905 – 1970)

11

Abstract Oil, 1936

oil on canvas

51 × 38½ in.

(129.6 × 96.9 cm)

inscribed on reverse:

HAUT/JF 20/Ferren 1936

As one of the few American artists to be accepted into the circle of the Parisian avant-garde during the 1930s, John Ferren remained relatively ambivalent toward the struggle of his compatriots to achieve recognition for American abstraction in this country.[1] Raised in Oregon and California, Ferren apprenticed himself to an Italian stonecutter living in San Francisco, and took up sculpture after a brief and unsatisfying experience in 1925 at the San Francisco Art School. In 1929 he went to Europe for a year, stopping first in New York to see the Gallatin Collection. While traveling in France and Italy he met Hans Hofmann, and together they attended an exhibition in Munich of work by Matisse. This exhibition prompted Ferren to switch from sculpture to painting and to investigate principles of color in his own work.[2] During this initial trip to Europe, he studied informally in Paris at several art academies and at the Sorbonne. In 1931, following a brief visit to California, Ferren settled in Paris, where he lived for the next seven years. There, he became acquainted with members of Abstraction-Création, and, through his marriage to Laure Ortiz de Zarate, the daughter of a Spanish artist, he met other Hispanic artists living in Paris, including Picasso, Miró, and Joaquin Torres-García. Ferren also met the Americans and future AAA members Albert E. Gallatin, Carl Holty, George L. K. Morris, and Charles Shaw during their stays in Paris. When Ferren returned to New York City in 1938, he initially continued his association with many of these artists, and he attended a few AAA meetings. Although his firsthand knowledge of European modernism made him a respected member, he did not feel the same frustration over the reception of abstract art in America as did his colleagues, and in 1940 he broke from the group.

Ferren maintained that he derived even his most abstract paintings ultimately from nature. He felt challenged to explore in abstract terms a variety of philosophical issues he believed were inherent in the natural order, such as the inner complexity comprising the organic whole, the unity underlying disparate elements of life, and chance and spontaneity. During his years abroad Ferren developed an abstract style based on Synthetic Cubism. By 1933, after having become close to Miró, Ferren had begun to incorporate biomorphic shapes into his own paintings. However, throughout the 1930s he also found inspiration in the visual language of such

diverse artists as Arp, Brancusi, Hélion, Kandinsky, and Mondrian.

Recalling the austere aesthetics of Constructivism as well as the shaded, cylindrical forms of Hélion and Léger, *Abstract Oil* illustrates the mature style that Ferren had developed in Paris. Typically, the artist created a dynamic composition organized around two or three sculptural entities consisting of facets that he modeled with gradation as well as with abrupt tonal contrasts. He evoked a visual rhythm through the placement of color and the distribution of curvilinear forms against a dark, solid background that balanced and unified the seemingly disparate elements.

Upon his return to the United States in 1938, Ferren began a series of academic figure and still-life studies. However, by the late 1940s he had shifted to a gestural style based on Abstract Expressionism, and he became a member and president of "The Club," which brought together key artists in this movement. Ferren returned in the 1960s to a more geometric mode akin to hard-edged and Op Art painting, in which he continued to explore the expressive interplay of color.

Notes

1 Gertrude Stein wrote in *Everybody's Autobiography* (New York: Random House, 1937; p. 127) that Ferren "is the only American painter foreign painters in Paris consider as a painter and whose paintings interest them."

2 Bailey, in *Lane and Larsen,* p. 76.

Selected References

*Bailey, Craig. *Ferren: A Retrospective* (exh. cat.). New York: The Graduate Center of the City University of New York, 1979.

———. "John Ferren," in *Lane and Larsen,* pp. 76–78.

SUZY FRELINGHUYSEN (1912 – 1988)

12

Collage with Stripes, 1949

oil, graphite, and paper

collage on gray chip board

8¹⁵⁄₁₆ × 5¹⁵⁄₁₆ in.

(22.7 × 15.1 cm)

Born into a prominent family in New Jersey, Suzy Frelinghuysen developed a consistent style of painting based on Synthetic Cubism, and she became known as one of the "Park Avenue Cubists." She initially worked in a realist manner. Without any formal training, she turned to abstraction in the mid 1930s as a result of the influence of her husband, George L. K. Morris, and of their shared enthusiasm for Cubism.[1] Although she did not become as actively involved in artists' organizations or in critical writing as did her husband, Frelinghuysen did join the AAA shortly after its founding in 1937, and she participated regularly in its yearly exhibitions.

She approached painting intuitively, adjusting the formal elements of her compositions until they suited her. Believing that "most art comes from nature,"[2] she abstracted most of her forms from the visible world. She consistently relied on the vocabulary and compositional arrangements of cubist collages, especially the Synthetic Cubism of Juan Gris. In both her paintings and her collages, she often fragmented the shapes of utilitarian items and combined them with found materials such as newspaper and magazine clippings, and patterned and printed papers.

In *Collage with Stripes* Frelinghuysen abstracted the composition to the degree that the generalized shapes only vaguely evoke the guitar constructions of Picasso and Braque, two artists whose work she frequently emulated. The flat, centrifugal arrangement of geometric forms, enlivened by repeated rhythmic patterning and an acidic coloration, creates a tactile immediacy typical of her style.

While seriously painting and making sculpture during the 1930s and 1940s, Frelinghuysen was also training as a professional singer. She had a brief but reputable career on the operatic stage and in concert halls from the late 1940s to the mid 1950s.[3]

Notes
1 Lane, p. 79.
2 Ibid., p. 80.
3 Ibid., p. 79.

Selected Reference
*Lane, John R. "Suzy Frelinghuysen," in *Lane and Larsen,*
 pp. 79–80.

12

ALBERT EUGENE GALLATIN (1881 – 1952)

13

Untitled, 1938

oil on canvas

12 × 10 in.

(30.4 × 25.4 cm)

inscribed on reverse: *A. E. Gallatin/March 1938*

Albert Eugene Gallatin was known primarily for his establishment, in 1927, of the Gallery of Living Art, the first institution in New York City to be devoted to progressive abstract art. His repute as a painter has remained secondary to that of his museum collection, just as he himself may have given priority to his various artistic endeavors. Gallatin was nicknamed a "Park Avenue Cubist" by members of the AAA because of his family's wealth, which enabled him to paint, collect, sponsor, and write about the arts rather than to practice law, the profession for which he had been trained.[1] Although initially attracted to the work of Aubrey Beardsley and James McNeill Whistler, Gallatin slowly came to appreciate modern art through the study of the French Impressionists, Cézanne, and such American modernists as Charles Demuth and John Marin.[2] In 1927 Gallatin installed his collection of art in a reading room on the campus of New York University. Free to the public and open during evening hours, the gallery provided an informal meeting place for intellectual exchange and for study of the newest developments in European art.[3] Many artists took advantage of this opportunity to view directly works related to those they could only see in reproduction in periodicals such as *Cahiers d'Art*. Through his painting, his museum, and the exhibitions he mounted, Gallatin became familiar with many vanguard artists in New York. He joined the AAA in 1937 and participated in the exhibitions of the group from 1938 to 1952.

Gallatin admitted that he had turned to painting in an effort to understand better the work he collected.[4] While studying and collecting cubist art in Paris in 1926, he began to paint in a realistic mode, but he still devoted most of his time to developing his collection. Unlike many of his contemporaries, he did not develop a personal style through experimentation in progressive stages. Instead, about 1936 he started painting in earnest, using a style based on the later, synthetic phases of Cubism, and he continued to work consistently in this manner until the late 1940s. He then painted reduced, simplified compositions of geometric shapes until his death in 1952.

Untitled dates near the outset of Gallatin's exploration of cubist compositional devices, and it relates closely in motif to a larger, more finished work illustrated in the AAA yearbook of 1939.[5] The present painting clearly was inspired by the decorative palette of Juan Gris and by Picasso's cubist collages of still-life subjects of the 1920s, some of them in Gallatin's own collection. Rather than fracturing forms across the canvas as in Analytical Cubism, Gallatin superimposed near the center of the composition flat planes of color within shallow space, in an additive and structured fashion typical of late Synthetic Cubism. Nevertheless, he transformed this synthetic cubist idiom into a personal language by abstracting objects to a greater degree than had the Cubists: his forms were no longer the identifiable, utilitarian items – glasses, pitchers, fruit – that frequently comprise cubist compositions. However, because Gallatin employed the standard cubist tabletop composition, this work may still be identified as a still life.

Notes

1 Other artists nicknamed "Park Avenue Cubists" were Suzy Frelinghuysen, George L. K. Morris, and Charles Shaw.
2 Gallatin published a catalogue of Beardsley's drawings in 1903, and he wrote three books on Whistler.
3 Gallatin changed the name of his gallery to the Museum of Living Art in 1933. In 1943, when New York University asked him to remove the collection in order to make room for more library books, he gave the 170 works to the Philadelphia Museum of Art.
4 Although the collection consisted of geometric, cubist, and constructivist art, the core consisted mainly of works by the Cubists Braque, Gris, Léger, and Picasso.
5 See *American Abstract Artists: Three Yearbooks (1938, 1939, 1946)* New York: Arno Press, 1969, p. 115.

Selected Reference

*Balken, Debra Bricker. *Albert Eugene Gallatin and His Circle* (exh. cat.). Coral Gables, Fla.: The Lowe Art Museum, University of Miami, 1986.

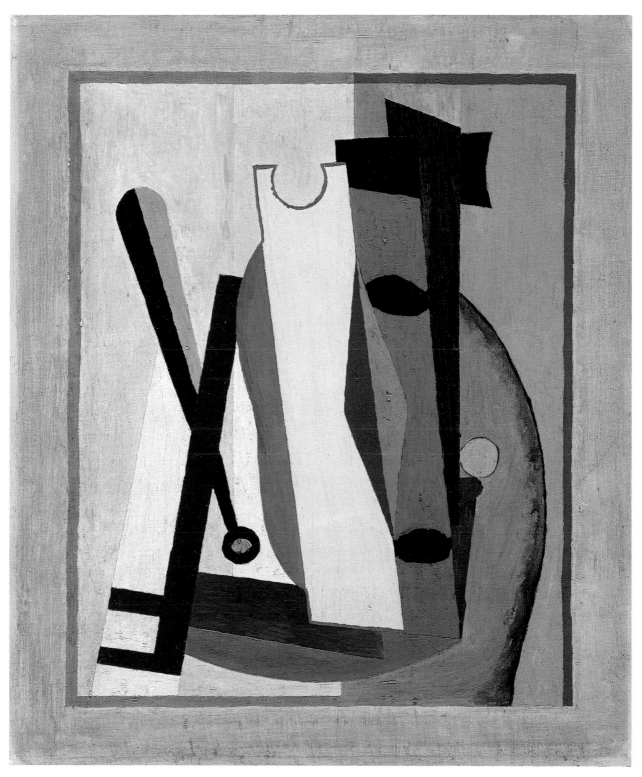

DWINELL GRANT (born 1912)

14

*Follow the Line
(Composition No. 114),*
1939

oil on masonite

21⁵⁄₁₆ × 19 in.

(54.1 × 48.2 cm)

inscribed on reverse: *#114*

An artist and a filmmaker devoted to the principles of nonobjective art, Dwinell Grant is one of the few painters to have been closely aligned with the mystical and spiritual philosophy underlying the Museum of Non-objective Painting, a bastion of support for artists working in nonobjective modes. As a youth Grant received informal training in landscape and portrait painting from his grandfather, and in 1931 he enrolled in the progressively inclined Dayton Art Institute. By the time he arrived in New York from Ohio in 1933 to study at the National Academy of Design, he had begun thinking about, if not painting, modernist ideas.[1] However, by 1935, when he became an instructor in art and the director of dramatics at Wittenberg University in Ohio, Grant was consistently painting in a nonobjective manner. During his five-year tenure at Wittenberg, he explained to his students such modern movements as Neo-Impressionism, Cubism, and Surrealism by making paintings right in the classroom.[2] Faced with criticism of his progressive art, Grant wrote to Hilla Rebay at the Museum of Non-objective Painting in New York, asking for monetary support. Enthusiastic about Grant's ideas and work, Rebay sent him a monthly stipend, purchased two of his drawings for Solomon R. Guggenheim, and included several of his paintings in a group exhibition at the museum in the summer of 1940. With Rebay's help, Grant moved to New York in 1941 in order to work as her assistant, a job he retained until 1942.[3] During the early 1940s he became friendly with Pereira, Sennhauser, and Xceron, all nonobjective artists and among the few AAA members associated with Rebay. Grant did not become too actively involved with the AAA because of its rivalry with the dogmatic Rebay; nevertheless, he exhibited with the group from 1939 to 1941.

Throughout his career, Grant has been interested in the balance and rhythm of form and color. Deriving his aesthetic philosophy from concepts found in Gestalt psychology, he believes that the surface of the work is a field within which he can use form and color to produce organization and, thus, unity. He recently described his intuitive approach to composing a work: "There is no reference to anything seen, except in the mind's eye. I start with a form — any form — in any color, and let it begin to tell me what to do next. When the composition says to stop, I stop."[4]

Grant's work from the mid to the late 1930s was active and expressive; he juxtaposed angular forms and geometric shapes with straight as well as gestural lines that float over expansive backgrounds of seemingly endless space. *Follow the Line,* however, marks Grant's transition from energized motifs in more complicated arrangements to hard-edged, simplified compositions. Still working within the same basic geometric vocabulary, he placed these compositionally and coloristically balanced elements against a richly textured surface. The artist created an image with strong cosmic, or even atomic, associations by setting planetlike and cloudlike shapes within an apparently indefinite expanse of blue. He also added implied elements of time and motion by contrasting, and at the same time balancing, the stable, geometric forms with the active, energized line that connects them.

Although Grant was aware of the many sources of nonobjective art available to him in New York (especially through the collection at the Museum of Non-objective Painting), he independently developed his own nonrepresentational style. In the late 1930s and early 1940s, he also began making nonobjective animated films.[5] He went to work for a commercial film company in 1942 and during the war made Navy training films. Later, he did scientific illustrations and made teaching films for the medical profession. Although he continued to paint, draw, and produce avant-garde films, his career in medical filmmaking took precedence, and he seldom exhibited his nonobjective work between the mid 1940s and the mid 1970s. Several shows of his work have been mounted during the past fifteen years.

Notes

1 Grant rejected his academic art training, leaving the National Academy of Design after five months.
2 Letter from Dwinell Grant to Elaine D. Gustafson, Mar. 19, 1991.
3 His main duties were to oversee the gallery and arrange and schedule traveling exhibitions. Letter from Dwinell Grant to Elaine D. Gustafson, Mar. 19, 1991.
4 Ibid.
5 While teaching at Wittenberg University, Grant acquired a 16 mm motion-picture camera for use during play rehearsals. This acquisition provided the possibility of adding time and movement to his abstract compositions.

Selected References

Fort, Ilene Susan. "Dwinell Grant," *Arts Magazine,* vol. 55, no. 6 (Feb. 1981), pp. 31–32.
*Mecklenburg. *Frost Collection,* pp. 80–84.

14

BALCOMB GREENE (1904 – 1990)

15

Monument in Black and White, 1935/1967

oil on canvas

49⅞ × 39⅞ in.

(126.7 × 101.3 cm)

inscribed on reverse:

Balcomb Greene/

1935–67

A highly educated and an articulate spokesman for modern art, Balcomb Greene had initially intended to follow in his father's footsteps and become a minister. Instead, he became an abstract painter in the early 1930s, after having completed graduate study in psychology and having begun a career teaching English literature and writing fiction.[1] Both he and Gertrude Greene, whom he married in 1926, were active, founding members of the AAA. Balcomb served as its first chairman and was reelected to the post twice. He also helped draft the charter of the group, served on the editorial committee for its 1938 yearbook, and designed the cover for its first publication. He resigned from the AAA in 1942, believing that its purpose, that of securing a foothold for American abstraction, had largely been fulfilled. During the 1930s, he worked for the Mural Division of the WPA Federal Art Project, and about 1940 he entered a master's program in art history at New York University.

Balcomb's decision to become an artist was influenced by Gertrude's artistic activities. In 1931 the couple moved to Paris, where Balcomb intended to write novels. However, he was attracted to the Parisian art scene and enrolled for independent study in the Académie de la Grande Chaumière, this being his only affiliation with an art school. Although struck by the work of both Picasso and Matisse, Balcomb developed a style influenced more directly by Gris, Mondrian, and other members of Abstraction-Création. In 1933 Balcomb started a series of collage compositions that prompted him to discard his earlier, seminaturalistic style and to focus on a more abstract and architectonic mode, work he described as his "straight-line, flat paintings."

During this early period of abstraction, Balcomb produced architectonic arrangements composed of angular planes of flat, muted color that meet and interlock in open, ambiguous space. Unfortunately, much of this abstract work was destroyed in 1941 in a fire at the studio he had shared with Albert Swinden. Balcomb chose to readdress some of the formal issues that had concerned him in the 1930s by recreating later in life a few of the lost pieces; *Monument in Black and White* is a later version (1967) of a composition originally created in 1935. As in many of his extant works from the 1930s, Balcomb here explored the regularity, balance, and clarity of simple geometric design. He also utilized tilted planes to suggest a sense of depth without destroying the essential flatness of the composition. Though Balcomb had minimized the artistic presence and the expressive effect of brushwork in many of his works of the 1930s by spraying pigment through stencils onto the canvas with an air gun, this later version was painted with a brush.

Ironically, Balcomb, who had been an advocate for abstraction in the 1930s, came to believe that nonrepresentational art was limited in its expressive potential. Thus, beginning in the 1940s and for the remainder of his career, he concentrated on the human figure, which he sometimes set within a landscape. In contrast to his naturalistic figurative works of the 1930s, the later paintings, which depict deformed figures within disjointed space, are more freely rendered and are surrealistic and erotic in tone. From 1942 to 1959 Balcomb continued his interest in academia, teaching art history at the Carnegie Institute of Technology in Pittsburgh.

Note

1 Balcomb attended Syracuse University from 1922 to 1926 and spent a year with Gertrude in Vienna, where he did graduate work in psychology. After returning to the United Sates, he taught at Dartmouth College from 1928 to 1931.

Selected References

*Baur, John I. H. *Balcomb Greene* (exh. cat.). New York: The American Federation of Arts, 1961.

*Hale, Robert Beverly; and Niké Hale. *The Art of Balcomb Greene.* New York: Horizon Press, 1977.

15

16

Progression, 1944–1946

painted wood construction

mounted on masonite

42 × 36¼ in.

(106.7 × 91.4 cm)

inscribed on reverse:

Progression (1946)/

Gertrude Greene

inscribed on reverse of

frame: *PROGRESSION*

Gertrude (Glass) Greene was one of the few members of the AAA who worked chiefly as a sculptor. She was also one of the first Americans of her generation to create abstract sculpture (some pieces as early as 1927) and to construct wood reliefs, the medium for which she is best known. Politically active in the Artists' Union, the Federation of Modern Painters and Sculptors, and the Sculptors Guild, she was a founding member of the AAA and the first salaried employee of the group.[1] She participated in the annual exhibitions of the AAA with her husband, the painter Balcomb Greene, until 1942, when they resigned their membership, believing that the goal of the group – to gain attention for American abstraction – had largely been attained.

Greene received her only formal art training in evening classes at the conservative Leonardo da Vinci Art School in New York City from 1924 to 1926. During 1931 and 1932, she and her husband lived in Paris, where she assimilated the principles of Constructivism, Suprematism, Neoplasticism, and biomorphic Surrealism, all of which significantly influenced her subsequent work.[2] Her earliest sculptures were three-dimensional and figurative, often combining wood with metal, and they were largely based on expressionist and cubist examples. By 1935, however, she had begun making relief constructions that were closely aligned to the cutout biomorphic work of Jean Arp. During the next few years, Greene was increasingly influenced by the spatial and mechanistic aspects of Russian Constructivism, and she began to alternate and combine curvilinear forms with geometric ones. She grew skilled in the handling of carpentry tools by cutting shapes out of wood, which she then glued or screwed in layers onto sheets of compressed wood. Although she frequently made preparatory drawings, between 1939 and 1941 she started making paper collages as a means of exploring her ideas.[3] After about 1940, a simple geometric approach deriving from both Neoplasticism and Constructivism predominated her work.

In combination, the studies for (see overleaf) and final work entitled *Progression* provide a unique glimpse of the artistic process behind Greene's work. A comparison of these objects reveals that she did not significantly alter her original idea during production. The most dramatic change is the elimination of the color red, which appears in the collage, from the final gray, black, and white composition.[4]

All three pieces reveal Greene's deep concern with balance and dynamism. Although they appear casually sprawled, the abutting and interlocking components were arranged in a calculated, linear fashion. The mechanistic patterns of these parallelograms, as well as the diagonal motifs that penetrate open space and connect disparate sections, were derived from the work of the Russian Constructivist El Lissitzky.[5] Greene's handling of space, with the use of diagonals to imply depth and of tilted planes to retain flatness, is also related to that found in Kasimir Malevich's suprematist works.[6]

Greene made constructions such as *Progression* during the period when she was commuting, with her tools and materials, by train between studios in New York City and Pittsburgh, where her husband was teaching. Consequently, she simplified her working methods and her compositions by substituting lath stripping – like that used in *Progression* – for complicated cutout wooden shapes.[7]

About 1946 Greene began to incorporate a freer, more gestural use of color into her reliefs, and by 1948, she had given up constructions in order to concentrate entirely on action painting. However, her paintings conveyed the same sense of architectonic structure as did her constructions, and her palette was often limited to black, white, gray, and the primary colors.

Notes

1 She tended the desk at the first annual exhibition of the AAA, which was held at the Squibb Gallery in 1937.

2 She encountered these movements again in the exhibition *Cubism and Abstract Art* at the Museum of Modern Art in 1936.

3 Unfortunately, few of these collages still exist.

4 Jacqueline Moss has suggested that the use of gray, black, and white refers to contrasting metals with which Greene had worked (see Moss, p. 124). However, these colors, as well as the primaries found in Greene's collage, were frequently employed by the Constructivists, Suprematists, and Neoplasticists, and she may simply have been emulating their palette.

5 Moss, p. 125.

6 Ibid.

7 Ibid., p. 126.

Selected References

*Hyman, Linda. *Gertrude Greene: Constructions, Collages, Paintings* (exh. cat.). New York: ACA Galleries, 1981.

*Moss, Jacqueline. "Gertrude Greene: Constructions of the 1930s and 1940s," *Arts Magazine,* vol. 55, no. 8 (Apr. 1981), pp. 120–27.

17

Pencil Study for Progression, 1944
graphite on paper
image: 12¹⁄₁₆ × 9¹⁵⁄₁₆ in.
(30.6 × 25.3 cm)
sheet: 13⁹⁄₁₆ × 11¼ in.
(34.5 × 28.6 cm)
signed in graphite at
lower left: *Gertrude
Greene 44-01*
inscribed in graphite at
lower right: *'44*
inscribed in ball-point pen
at lower right: *10*

18

Collage Study for Progression, 1944
paper collage on heavy-
weight beige cardboard
12⅛ × 9¹⁵⁄₁₆ in.
(30.7 × 25.3 cm)
signed in graphite at
lower right: *44-02
Gertrude Greene*

17

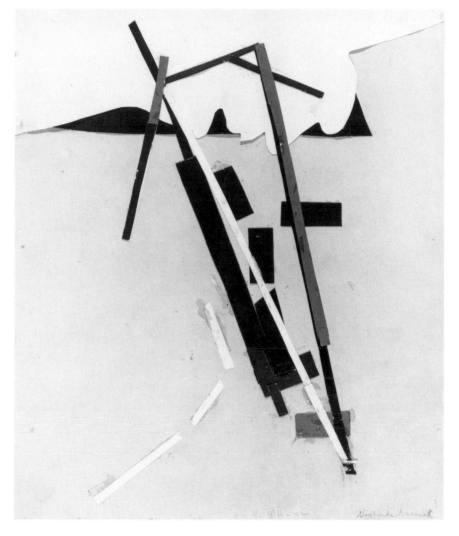

18

CARL HOLTY (1900 – 1973)

19

Mountain Lake, 1947

oil on masonite

14¹⁄₁₆ × 18 in.

(35.7 × 45.7 cm)

signed at lower right:

Carl Holty

inscribed on reverse:

Carl Holty 47/Mountain

Lake/14 × 18

A painter who achieved some success exhibiting in Paris and New York in the 1930s, Carl Holty brought to the AAA extensive firsthand knowledge of European modernism and important friendships with the progressive artistic communities of Munich and Paris. Born in Freiburg, Germany, of American parents and raised in Milwaukee, Wisconsin, Holty attended the Milwaukee Art School as a youth. He studied in 1919 at the school of the Art Institute of Chicago and from 1920 to 1921 in New York at the Parsons School of Design and the National Academy of Design. Having worked briefly in Milwaukee as a portraitist, Holty left in 1926 for Munich in order to study at the Royal Academy. Instead, he was persuaded by his friend Vaclav Vytlacil to join Hans Hofmann's school. Although Holty attended for only one year, his view of art was transformed by Hofmann's lessons on the expressiveness and purely formal interrelationships of space, color, and form; Holty turned to these principles throughout the rest of his career.

In 1930 he moved to Paris where, in 1932, under the sponsorship of Robert Delaunay, he became one of the few Americans to join the international group Abstraction-Création. Following a decade of extensive travel abroad, Holty returned in 1935 to New York, where he was invited by Vytlacil to participate in the initial discussions concerning the formation of the AAA. A founding member of the group, Holty served as its second chairman in 1938 and participated in its exhibitions until 1944.

Holty's preoccupation with the structure of his compositions persisted throughout his career, a fact he attributed to his strong German heritage.[1] By 1928 he had been drawn to the spatial and structural aspects of Synthetic Cubism, which remained a strong influence on him throughout the next two decades. Holty credited the decorative work of Juan Gris with teaching him most of what he knew about Cubism. He soon developed a personal style of broad, curvilinear, hard-edged forms that fell within the aesthetic parameters encompassing the work of many members of Abstraction-Création. Upon his return to New York in 1935, he briefly came under the influence of Miró's biomorphic abstraction, and he began to combine crisply delineated biomorphic and geometric shapes over larger surface areas. Although his compositions at that time were highly abstract, Holty argued that nature con-

tinued to be the basis of his art, as the titles of his paintings bear out.[2]

In the late 1940s Holty began to loosen both his sense of strict compositional structure and the precision of his hard-edged forms in favor of a more painterly approach. Painted after his active association with the AAA, *Mountain Lake* preserves the swinging rhythms and compositional structure of Holty's precisionist manner of the preceding fifteen years, but it reveals a more textural surface and an expressionist application of color. The solid, architectonic design; decorative color; and flat, expansive composition reflect lingering influences of Synthetic Cubism and Neoplasticism. However, the scumbled effect of Holty's brushwork, which reveals layers of color beneath the surface, indicates the new expressive direction that his work was beginning to take.

By the 1960s Holty was painting exclusively in an expansive, fluid style that favored thin washes of paint; this was akin to the work of the color field painters rather than to the tactile, gestural brushwork of the Abstract Expressionists. Although Holty responded to the artistic concerns of both these movements, because of his abiding concern with structure, he never fully acknowledged the effect they had on his later work.

Notes

1 Lane, p. 174.
2 Later in life, Holty claimed to have followed Mondrian's example by eliminating all references to nature in his work. However, Holty never achieved a truly nonobjective style.

Selected References

*Danoff, I. Michael. *Carl Holty: The World Seen and Sensed* (exh. cat.). Milwaukee: Milwaukee Art Museum, 1981.
*Kaplan, Patricia. *Carl Holty: Fifty Years* (exh. cat.). New York: The Graduate Center Mall, The City University of New York, 1972.
Rembert, Virginia Pitts. "Carl Holty," *Arts Magazine,* vol. 55, no. 4 (Dec. 1980), p. 11.

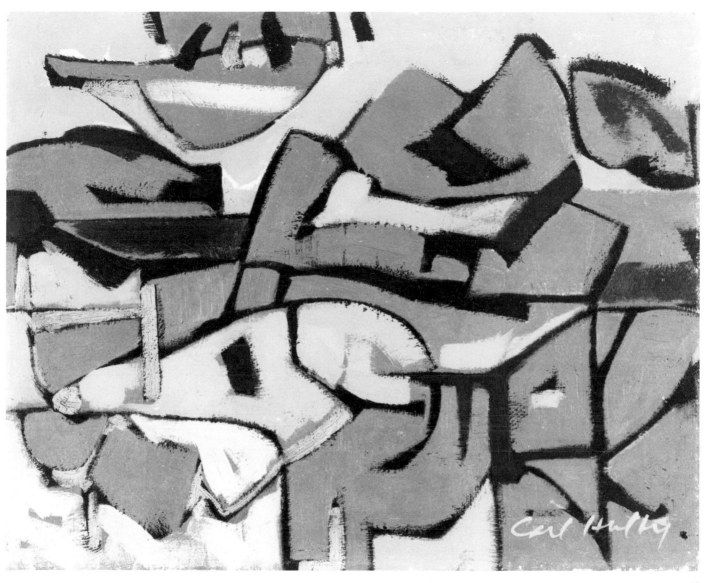

19

FREDERICK KANN (1886? – 1965)

20

Untitled, 1931

oil on canvas

21¾ × 18⅛ in.

(55.3 × 46.1 cm)

signed and dated at

lower left: *F. KANN/31*

Born in Jablonec nad Nisou (Gablonz), Czecho-slovakia, Frederick Kann was affiliated with many of the progressive European and American art movements of his day, but he never received sustained national or international recognition.[1] He studied architecture, painting, sculpture, and the applied arts at the Technical College of Prague and at the art academies in Munich and Prague. He became involved with the avant-garde German expressionist group Die Brücke, and he reputedly exhibited with them in 1905 in Munich. In 1910 Kann immigrated to Canada, where he worked as a commercial artist. At some point, he relocated to New York City, continuing his free-lance and commercial work there until 1926. By 1928 he had settled in Paris, where he taught studio art during the next several years.

Shortly after his arrival in that city, Kann began to paint abstractions and to exhibit regularly in various galleries. His contact with the international artistic vanguard is documented by his membership in Abstraction-Création, with which he exhibited in 1934. In 1936 he was invited to teach industrial art and design at the Kansas Art Institute, where the regionalist Thomas Hart Benton was a fellow instructor. Kann settled in Los Angeles in 1942, and there opened the Frederick Kann-Frank Martin Gallery, also called the Circle Gallery, two years later. This gallery was one of the few to exhibit abstract art at the time. In 1953 he established the Kann Institute of Art in West Hollywood.

Despite the fact that Kann was of an older generation and lived in the Midwest, he was an early member of the AAA and participated in the first annual exhibition in 1937. He was elected liaison to fellow group members who resided outside the New York area. Later, he also became responsible for organizing AAA exhibitions that toured the country. About 1941 he discontinued showing with the group because of the expense of packing and shipping his works across the country, but he exhibited with them again in 1946 and 1947.[2]

Kann's early contact with European art and artists provided the foundation for his innovative concept of the creation of art. He attempted in his nonobjective works to depict the essence of his subject by suggesting the internal working process of nature rather than by imitating its outward appearance. He experimented with geometric patterns, with which he represented both the fluctuating rhythms inherent in nature and the continual realignment of these rhythms due to change. He wrote:

> Abstract art has grasped the essential nature of things which can be found and conceived only when we learn to look behind or beyond their mere outer form (academic banality). Only then will we be able to express that which we call beauty, or rhythm or harmony, or love of life. Then pictures are not pictures of outer world fragments, but the artist himself (representing generic creative forces) becomes the picture, and lines, forms, tones and textures are the instruments with which he creates his song or symphony.[3]

From what little is known about Kann's artistic development, it appears that he progressed from a style based on the fractured, overlapping, additive forms of Synthetic Cubism to one founded on the interpenetrating, architectonic planes of Russian Constructivism. Painted while he was in Paris, *Untitled* documents this later style, one that Kann also explored in sculpture. This picture clearly reveals the artist's formal expression of his philosophical view of the essence of nature, specifically through the contrast of thin, static planes interlaced with undulating, ribbonlike forms. Kann heightened the immediacy of these invented forms through precise modeling and through the illusion of their recession into space. Bathed in a radiant light, the thin planes are surrounded by a solid background that is enhanced by a painterly, textured surface. In later work Kann arranged his forms in less tightly organized compositions spread over the entire surface of the canvas.

Notes

1 I would like to thank Pamela Esther Nask for generously sharing her research on Frederick Kann with me; much of this entry is derived from information she assembled. I would also like to thank Martin Diamond for putting me in contact with Ms. Nask. There is some uncertainty as to what year Kann was born; both 1884 and 1886 have been suggested.
2 AAA meeting notes of December 22, 1940, Archives of American Art Microfilm, NY 59-11.
3 Kann, "Los Angeles Museum's Third Group Show."

Selected References

Kann, Frederick (artist's statement), in "Abstract Art," *Art and Architecture,* vol. 61 (June 1944), pp. 16–17.

———— (artist's statement), in "Los Angeles Museum's Third Group Show," *Art and Architecture,* vol. 61 (Oct. 1944), pp. 20, 32.

————. "In Defense of Abstract Art," in *American Abstract Artists: Three Yearbooks (1938, 1939, 1946),* pp. 27–28. New York: Arno Press, 1969.

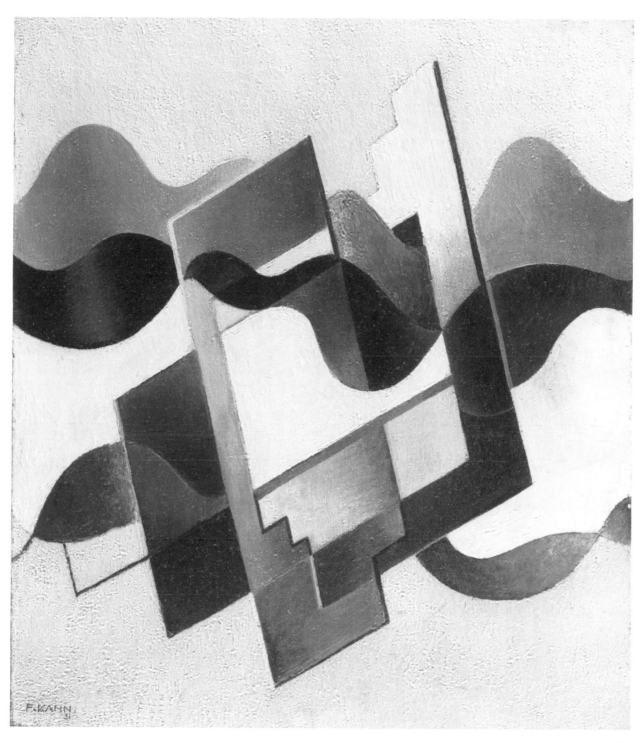

20

LEE KRASNER (1908 – 1984)

21

Untitled (Sketch for Mural at Radio Station WNYC, Studio A), 1941

gouache and graphite on paper

image: 10⅜ × 5¾ in. (26.4 × 14.6 cm)

sheet: 13½ × 10¾ in. (34.3 × 27.3 cm)

signed and dated in graphite at lower right:

L.K. '41

Only in the last two decades or so has Lee Krasner become known as a gifted painter in her own right, rather than solely as the wife of Jackson Pollock and executor of his estate. One of the most progressive artists of the mid twentieth century, Krasner is known today chiefly as an Abstract Expressionist. She began painting abstractly in 1937, and by 1943 was working in a totally nonobjective style. She became interested in art at an early age and commuted from Brooklyn to Manhattan to attend Washington Irving High School for Girls because it offered a studio art major. From 1926 to 1929 she studied on scholarship at the Woman's Art School at Cooper Union, a vocational school that emphasized design and the applied arts. She then pursued the traditional course of study at the National Academy of Design for three years.[1] Following the standard route for women interested in the arts, she earned a high-school teaching certificate from City College of New York. Krasner never taught, however, because from 1934 to 1943 she found periodic work with the Public Works of Art Project and the WPA Federal Art Project as a textbook illustrator and as a mural assistant and supervisor.[2] In these positions she came into contact with many artists, eventually joining the AAA in 1940. As a student in Hans Hofmann's studio from 1937 to 1940, Krasner discarded her conventional, realist subject matter and began to concentrate on abstractions from nature; this transition was also prompted by her encounter with European modernism at the Museum of Modern Art.

During the late 1930s and early 1940s, Krasner, distressed at always having to implement other artists' projects, made numerous studies for abstract murals in the hope that she herself might receive a commission through the WPA. *Untitled* belongs to a group of four other related sketches for a proposed mural for Studio A at the radio station WNYC.[3] Because by 1939 funds for the WPA were being redirected toward other government priorities, Krasner's mural never progressed beyond the study stage.

This gouache reflects the artist's exploration during the late 1930s and early 1940s of the wide range of stylistic sources that confronted her as a student at Hofmann's studio and in the European works she saw at museums. The black lines, which define the planes of color and contribute to a sense of compositional flatness, appear in much of

Krasner's work at this time and may derive from Picasso's cloisonné-like Cubism of the 1920s.[4] The geometric structure, the overlapping color planes, the ambiguous space, and the receding and advancing of color all indicate that she was looking at the work of Mondrian and the Russian Suprematists. Though implied motion and visible brushwork suggest the influence of suprematist paintings, the coherent, highly structural architectonic format may reflect the artist's interest in neoplasticist principles and the overriding influence of hard-edged Synthetic Cubism.[5]

In the late 1940s Krasner matured as an Abstract Expressionist, employing spontaneous gestures in thickly painted compositions that covered the entire surface of her canvases. No longer abstracting her work from nature, she now drew on forms generated by her imagination. In the late 1950s she moved away from such action paintings toward color field compositions in which thin washes of color were absorbed into the canvas. Later, she turned to collage as a means of combining the energy of her action paintings with the optical vibrancy of her color field paintings by pasting torn and cut fragments of the former on top of the latter. She continued to experiment with both styles until her death in 1984.

Notes

1 Krasner also attended the Art Students League for one month in the summer of 1928.

2 As an assistant painter, she enlarged sketches, most of them representational, by other artists and supervised their execution as murals.

3 The sketches are all untitled and were in the collection of the artist at the time of her death; for illustrations see Rose, pp. 36–37. Krasner's mural was to be the fifth in a group of five. The other four murals were completed in 1939 by John von Wicht, Louis Schanker, Byron Browne, and Stuart Davis; those by von Wicht, Schanker, and Browne remain *in situ*.

4 Rose, p. 38.

5 Krasner met Mondrian in 1940 through the American Abstract Artists.

Selected Reference

*Rose, Barbara. *Lee Krasner: A Retrospective* (exh. cat.). Houston and New York: Museum of Fine Arts, Houston, and Museum of Modern Art, New York, 1983.

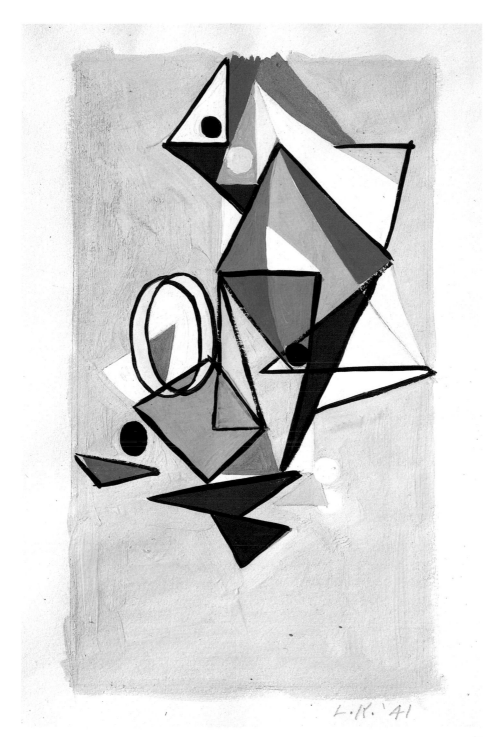

L·K· '41

21

22

Untitled, 1941

watercolor and graphite

on paper

8³⁄₁₆ × 9¹⁵⁄₁₆ in.

(20.9 × 25.3 cm)

signed and dated in

graphite at lower right:

Lassaw 41

23

Untitled, 1943

watercolor and graphite

on paper

7¾ × 10³⁄₁₆ in.

(20 × 25.8 cm)

signed and dated in

graphite at lower right:

Lassaw 1943

As early as 1933, Ibram Lassaw became a pioneer among the second generation of American abstract artists in his exploration of nonobjective sculpture. Born in Alexandria, Egypt, and raised in Brooklyn, New York, he studied traditional clay modeling first at the Brooklyn Children's Museum and then from 1927 to 1932 at the Clay Club under the direction of Dorothea Denslow. In 1930 and 1931 Lassaw was enrolled in the City College of New York and attended night classes at the Beaux-Arts Institute of Design.[1] From the mid 1930s until he was drafted into the Army in 1942, he worked as a teacher and sculptor for the WPA Federal Art Project. Lassaw became intimately involved in the founding of the AAA and served as its chairman from 1946 to 1949.[2]

He was introduced to European abstraction through the exhibition of Katherine Dreier's collection at the Brooklyn Museum in 1926. However, Lassaw's familiarity with and understanding of the elements of Surrealism, Constructivism, and Neoplasticism, which he would incorporate into his own work, came through many sources, including the Gallery of Living Art at New York University as well as periodicals such as *Cahiers d'Art* and *Plastique.* While Alexander Calder's colorful motorized mobiles opened Lassaw's eyes to the kinetic potential of sculpture, Moholy-Nagy's book *The New Vision* prompted his interest in new materials and in the sculptural process. Ultimately, out of his extensive study of art history and aesthetics as well as science, philosophy, astronomy, and human anatomy, Lassaw developed a personal vision of the world as an ecological entity.

His abstract sculpture from the early 1930s drew upon the surrealist-inspired biomorphic forms of Arp, Brancusi, and Miró. By the early 1940s, Lassaw had integrated organic forms with rectilinear elements adapted from Constructivism and Neoplasticism. Because few of his sculptures from the 1930s and early 1940s still exist, drawings such as the two shown here, in which he sketched out preliminary ideas, are particularly important in helping to trace his stylistic development. These drawings illustrate his interest in combining surreal, biomorphic forms within open spatial configurations. Though the drawings reflect only minimal traces of the structural geometry of neoplasticist and constructivist design principles, they indicate Lassaw's intuitive exploration of the internal structure and negative space of open form. In the 1940s the artist grew increasingly dissatisfied with the juxtaposition of the disparate aesthetics of geometry and biomorphism. Eventually, he synthesized the two in his development of an open, calligraphic style.

Starting in the 1950s, by which time his mature style had been fully formed, Lassaw began to weld incrustations of liquefied metal onto wire frames. Maintaining an open configuration in his sculpture, he then added an element of color onto the linear, weblike constructions by incorporating gems and using various chemically treated alloys. The calligraphic, spontaneous style of Lassaw's later welded pieces, for which he is best known, has been compared by some to the gestural work of the abstract expressionist painters.

Notes

1 About 1943 he was affiliated as a student with the Amédée Ozenfant School of Art.

2 Lassaw was also a charter member of the Abstract Expressionist group "The Club."

Selected References

*Heller, Nancy Gale. "The Sculpture of Ibram Lassaw" (Ph.D. diss.). New Brunswick, N.J.: Rutgers University, 1982.

Sandler, Irving. "Ibram Lassaw," in *Three American Sculptors,* pp. 45–57. New York: Grove Press, 1959.

22

23

ALICE TRUMBULL MASON (1904 – 1971)

24

Untitled, about

1937–1939

gouache and graphite

on paper

image: 15¹⁵⁄₁₆ × 18¹⁵⁄₁₆ in.

(40.2 × 48.0 cm)

sheet: 17¹⁄₁₆ × 21 in.

(43.5 × 53.4 cm)

inscribed in graphite

on reverse: *#48*

A founding member of the AAA, Alice Trumbull Mason knew many of the avant-garde artists working in New York City. However, in her effort to balance her art with her family life, she achieved relatively modest recognition as a painter and a printmaker.[1] Born into a prominent Connecticut family whose ancestors included the Federal painter John Trumbull, she received a broad cultural and intellectual upbringing that included extensive European travel. She began painting in 1921 at the British Academy in Rome during one of her family's trips abroad. Following her return to the United States in 1923, she continued a conventional course of study in New York at the National Academy of Design and with the realist Charles Hawthorne. Mason's most important teacher, however, was Arshile Gorky, who, in 1927 and 1928, introduced her to Kandinsky's mysticism and taught her to analyze the inherent structure of form. Although Gorky himself was not yet working abstractly, he encouraged Mason to explore the relationship between abstract, organic forms and expressive line. Her emerging style was also influenced by a trip in 1928 to Italy and Greece, where she was intrigued by the underlying geometry and structure of archaic Greek, Byzantine, and Italian primitive art. By 1929 she had begun to paint entirely abstract compositions. However, she stopped painting altogether between 1932 and 1935 in order to raise her children.[2]

Strongly influenced by Synthetic Cubism, the amorphous color areas of Kandinsky, and the meandering line and biomorphic forms of Miró, the untitled gouache shown here epitomizes the concerns Mason explored throughout her oeuvre. She was interested in formal issues such as the changing effects of color and composition examined in terms of the balance, arrangement, and displacement of color and line. In this work, she employed whimsical, organic forms and ambiguous color areas to create dynamic tensions and forces. Through the calculated juxtaposition of subtle color and biomorphic forms floating in unstructured space, Mason created meditative, sensuous paintings that balance introspection with detachment.

In later works, Mason explored similar artistic problems but changed her stylistic vocabulary. In the 1940s her paintings gradually became more geometric and brighter in palette, with flat, delin-

eated areas of color replacing the painterliness of the earlier works.[3] During this decade she also explored her own theories of "four-way balance" and "architectural abstraction," which were inspired by Mondrian's neoplasticist principles. She began to sign her pictures in various places so they could be hung in several different orientations without destroying a sense of balance. By the 1950s Mason had become strongly influenced by Mondrian's geometry, although she did not adopt his strict orthogonal structure. Over the years, her work became increasingly decentralized and reductive in composition. Although she never stopped painting, she withdrew from society in the 1960s, remaining in seclusion until her death in 1971.

Notes
1 Mason served as treasurer (1939), secretary (1940–1945), and president (1959–1963) of the AAA.
2 During her hiatus from painting, Mason began writing poetry.
3 She also started creating similar compositions in prints at Stanley Hayter's Atelier 17.

Selected References
*Brown, Marilyn R. "Three Generations of Artists," *Woman's Art Journal,* vol. 4, no. 1 (Spring–Summer 1983), pp. 1–8.
*———. *Alice Trumbull Mason, Emily Mason: Two Generations of Abstract Painting* (exh. cat.). New York: Eaton House, 1982.
Hill, May Brawley. *Three American Purists: Mason, Miles, von Wiegand* (exh. cat.). Hartford, Conn.: Fox Press, 1975.
*Pincus-Witten, Robert. *Alice Trumbull Mason* (exh. cat.). New York: Whitney Museum of American Art, 1973.

GEORGE L. K. MORRIS (1905 – 1975)

25

Floating Figures, 1935

oil on canvas

12⅛ × 9⅛ in.

(30.8 × 23.2 cm)

signed at lower right:

Morris

dated at lower left: *1935*

inscribed on reverse:

George L. K. Morris /

Floating Figures / 1935

26

Abstraction, 1935

pastel on artist's board

14¹/₁₆ × 11¹/₁₆ in.

(35.7 × 28.1 cm)

inscribed in graphite

on reverse: *1935*

Among the group of affluent AAA artists who were dubbed the "Park Avenue Cubists," George L.K. Morris became an articulate advocate for abstract art.[1] His informed art criticism, which placed abstraction within a coherent historical context; his financial support; and his considerable European connections all contributed more to the cause of American modern art than did his painting style. A writer, editor, collector, painter, and sculptor, Morris helped found the AAA in 1937, and he contributed articles to its yearbooks, participated in its exhibitions, and served as its president from 1948 to 1950. A graduate in humanities from Yale University, he attended the Art Students League in 1928, and traveled to Paris in 1929 with his close friend Albert E. Gallatin. There, Gallatin introduced him to the artists Arp, Brancusi, Braque, Delaunay, Mondrian, and Picasso. Morris remained in Paris after Gallatin's departure in order to study at the Académie Moderne with Fernand Léger and Amédée Ozenfant, artists working in a style based on the later phases of Cubism. Upon his return to New York about 1930, Morris began working in an abstract idiom. During the 1930s and early 1940s, he continued to study and travel intermittently in Europe and throughout the world. In 1935 he married Suzy Frelinghuysen, a painter and collagist who also joined the AAA. Morris taught at the Art Students League from 1943 to 1944 and at St. John's College in Annapolis, Maryland, from 1960 to 1961.

By 1935, when Morris executed both the pastel and the oil shown here, he had dispensed with an earlier, figurative, illusionistic style in order to explore the vast expressive possibilities of Cubism. He was attracted to the formal issues of balance, unity, and coherence, as well as to the structural order of form inherent in Cubism. In *Abstraction* Morris exploited the subtleties of the pastel medium for the purpose of examining the distribution of tonal weight and color, the delicate modeling of volumes, and the organization of composition in shallow space, all characteristics he assimilated from Synthetic Cubism.[2] In the oil *Floating Figures* he focused on the rhythmic interaction of simplified, crisply delineated forms in shallow space instead of working with a traditional, static cubist design. Utilizing a subtle illusionistic device, he painted shadows around the edges of several elements, creating a suggestion of depth via trompe l'oeil, an effect he expanded upon in later paintings.

Morris continued to explore similar structural issues throughout the remainder of his career. Though his work evolved essentially from European influences, he strove to integrate distinctly American elements into his style. He incorporated into his art American wallpaper patterns and Native American motifs, which he viewed as part of the international language of primitivism. In the 1960s and 1970s he stressed the surfaces of his pictures through the application of heavy impasto, pattern, and the simplification of composition.

Notes

1 The other "Park Avenue Cubists" included Suzy Frelinghuysen, Albert E. Gallatin, and Charles Shaw.
2 Jackson, p. 150.

Selected References

*Hoopes, Donelson F. *George L. K. Morris: A Retrospective Exhibition of Paintings and Sculpture, 1930–1964* (exh. cat.). Washington, D. C.: The Corcoran Gallery of Art, 1965.

Jackson, Ward. "George L.K. Morris: Forty Years of Abstract Art." *Art Journal,* vol. 32 (Winter 1972–1973), pp. 150–56.

26

25

27

Abstract, 1938

oil on canvas

30 × 36 in.

(76.2 × 91.4 cm)

signed at lower right:

I. RICE PEREIRA

An independent thinker and artist, Irene Rice Pereira created a visionary art that fused the seemingly opposing realms of the technological and the metaphysical. The nonobjective geometric style she developed in the late 1930s combined a rectilinear precision with an unexpected interest in surface texture. Born in Boston, Pereira had to postpone her academic interests in order to support her family following her father's death in 1922. She turned to the study of art in 1927, when she enrolled at the Art Students League in the classes of modernists Richard Lahey and Jan Matulka, who introduced her to progressive European styles. There, she also met fellow students Dorothy Dehner, Burgoyne Diller, and David Smith, who would also pursue abstraction.

In 1931 Pereira went abroad for the first time, traveling to Europe and North Africa to seek personal growth as an artist. After studying briefly with the Purist Amédée Ozenfant in Paris, Pereira visited Italy, where she was struck not so much by the work of the Renaissance masters as by the bright colorism of the earlier Italian primitives. Having traveled to North Africa, she incorporated into her aesthetic sensibility the intensity of light and the immensity of space she had found in the Sahara. Her growing interest in machine-age materials, in the synthesis of the sciences and the arts, and in the social implications of art and technology coalesced during the mid 1930s, when she taught at the Design Laboratory in New York. Pereira had helped establish this school of industrial design in 1935 under the auspices of the WPA. The curriculum paralleled the system of the Bauhaus, in which students — taught in laboratories rather than in studios — were introduced to the basics of physics and chemistry and encouraged to experiment in their art with new industrial materials. By 1937, Pereira's own painting had emerged from a robust semiabstract manner — often depicting nautical and machine images — to a nonobjective style reflecting Bauhaus principles. About this time she began experimenting with different reflective materials — glass, plastics, and gold leaf — and exploring her interest in the movement of light through space. She also found support for her concern with metaphysical questions in C. Howard Hinton's book *The Fourth Dimension* (1906), which profoundly influenced her. By 1939 she had joined the AAA.

Abstract dates from Pereira's earliest nonobjective period, and it typifies the essential attributes of her mature style, which she would refine in the next decade. This composition expresses the artist's exploration of light, texture, and the penetration of space within a strict geometry. Pereira superimposed two white, seemingly translucent parallelograms over a complex circuit of rectilinear forms, thereby setting up a dynamic tension between the flatness of the canvas and a sense of indefinite space. By scratching into the paint, she created surface texture in an attempt to suggest vibrating light. In later work, she transformed such surface manipulation into the spattering or spraying of pigment onto areas of the canvas and into gestural brushwork. By the mid 1940s the artist had abandoned the dark, rich red, blue, white, and black of *Abstract* in favor of brighter, more luminous hues.

For the remaining thirty years of her career, Pereira further refined this vocabulary in her continued search for an artistic expression that would reflect the radical scientific discovery of the nuclear age. A prolific writer, she also published several books, among them *The Nature of Space: A Metaphysical and Aesthetic Inquiry* (1956) and *The Lapis* (1957).

SES

Selected Reference

*Baur, John I. H. *Loren MacIver – I. Rice Pereira* (exh. cat.). New York: Whitney Museum of American Art, 1953.

27

AD REINHARDT (1913 – 1967)

28

Abstract Painting, 1935

oil on canvas

16 × 20 in.

(40.6 × 50.8 cm)

signed and dated at lower

right: *Reinhardt '35*

inscribed on reverse:

Reinhardt/1935

inscribed on stretcher:

45 7th AV, N.Y.,

REINHARDT

Informed about art history, politically active, and one of the few artists of his generation to begin his career by painting abstractly, Ad Reinhardt believed in the primacy of abstract art. He repeatedly insisted that art should be judged on its own formal merits and should not carry the excess baggage of representationalism or social and literary content. Adhering to this belief, he relied throughout his life on writing and on satirical cartoons to express his artistic and moral concerns.

Reinhardt began his painting career in 1937. He had studied art history at Columbia University from 1931 to 1937 and painting with Karl Anderson and John Martin at the National Academy of Design in about 1935. He also took classes in 1936 with modernists Francis Criss and Carl Holty at the American Artists' School. During the late 1930s Reinhardt worked for the Easel Division of the WPA Federal Art Project, and he did free-lance industrial and commercial art. With the sponsorship of Holty, he joined the AAA in 1937.[1]

Dating from the outset of Reinhardt's formal art studio training, *Abstract Painting* is one of his earliest abstractions. Balanced through color and position within a shallow field, the stylized, solid-toned planes and curving shapes define his own artistic language, which was based on Synthetic Cubism. Unlike the somber palette of the Cubists, an array of rich, related colors enlivens his design. In the center of the composition amoeba-like shapes interlock with each other as well as with the crisp, rectilinear forms surrounding them, and they recall the organic forms of Arp and Miró. Reinhardt continued to paint in this generally cubist style until about 1938 or 1939, when, influenced by Stuart Davis, he began fragmenting his compositions and expanding them to cover the entire surface of the canvas.

Throughout the last thirty years of his career, Reinhardt remained committed to a formal examination of an impersonal or neutral abstraction. Though briefly aligned with the Abstract Expressionists, he rejected the emotionalism and the individuality inherent in their gestural work. His paintings progressed through a series of essentially geometric styles that ultimately led to the starkly elegant, single-color, symmetrical paintings of the 1950s and 1960s for which he is best known today.[2]

Notes

1 From 1942 to 1947 Reinhardt was an artist-reporter for the New York newspaper *PM,* and in 1947 he began teaching art history at Brooklyn College.

2 Reinhardt is seen as a precursor to the Minimalists as a result of these somber, reductive paintings. These works are related to Josef Albers's *Homage to the Square* series, which was begun in 1949.

Selected References

*Lippard, Lucy R. *Ad Reinhardt.* New York: Harry N. Abrams, 1981.

*———. *Ad Reinhardt: Paintings* (exh. cat.). New York: The Jewish Museum, 1966.

Sims, Patterson. *Ad Reinhardt: A Concentration of Works from the Permanent Collection of the Whitney Museum of American Art* (exh. cat.). New York: Whitney Museum of American Art, 1980.

28

RALPH ROSENBORG (born 1913)

29

Nature Abstraction, 1938

oil on canvas

24 × 18⅛ in.

(61 × 46 cm)

signed and dated at

lower left:

Rosenborg 1938

inscribed on reverse:

Rosenborg/1938/New

York City, 1938

inscribed on stretcher:

Ralph Rosenborg 4 Park

Avenue New York City/

size = 18 × 24 inches

year = 1938 title =

Nature Abstraction

From an early date, Ralph Rosenborg was highly respected and admired among his compatriots for his progressive, expressive style of painting. As a high-school student, Rosenborg attended Saturday art classes at the American Museum of Natural History in New York City in 1929. Between 1930 and 1933 he continued to study privately with Henriette Reiss, who had worked with Kandinsky. Reiss not only offered Rosenborg technical training, but also broadened his knowledge of art history, literature, music, and, most significantly, European modern art. During the mid 1930s, Rosenborg held various commercial and teaching jobs, and he began to exhibit his work regularly in New York. He was also employed by the Public Works of Art Project and then by the Teaching, Easel, and Mural divisions of the WPA. A founding member of the AAA, he also became a member of "The Ten," a group of artists who exhibited together in 1937 and 1938 to promote American abstraction.

During the 1930s, Rosenborg produced expansive, nonrepresentational compositions that translated his subjective experiences of nature into abstract arrangements. His lifelong connection with and appreciation of nature may have been formed during his youth, when he wandered about the large country estates where his mother worked as a cook.

The warm, harmonious palette and oscillating repetition of shapes in *Nature Abstraction* convey to the viewer a suggestion of the internal, fleeting rhythms of nature. The composition of forms emanating from the center of the canvas is characteristic of Rosenborg's work of this period. Despite the inherent opacity of the oil medium, Rosenborg achieved through his command of materials and glazes an effect of transparency and light which recalls the work of the French Orphist Robert Delaunay. The quality of translucence, in combination with the sense of radiating motion, conveys an immediacy that is enhanced by the broad execution and warm hues. The apparent spontaneity of the work belies the artist's careful planning process that is typical of his working style.

During the 1930s and 1940s Rosenborg fluctuated between two modes: expressionist canvases evoking the rhythms and colors of nature, and more structured, deeply toned paintings depicting dreamlike landscapes that recall elements of the work of Klee and Kandinsky.[2] During the 1950s, 1960s, and 1970s, Rosenborg painted landscapes and floral subjects in a gestural, heavily impastoed manner related to Abstract Expressionism.

Notes
1 Sawin, *Arts Magazine,* p. 46.
2 Mecklenburg, *Frost Collection,* p. 151.

Selected References
*Sawin, Martica. "The Achievement of Ralph Rosenborg," *Arts Magazine,* vol. 35, no. 2 (Nov. 1960), pp. 44–47.
———. *Ralph Rosenborg: Watercolors 1940–88* (exh. cat.). Princeton, N.J.: Princeton Gallery of Fine Art, 1988.
Wechsler, Jeffrey. *Ralph Rosenborg: Oil and Watercolor Paintings from the 1960s* (exh. cat.). New York: Snyder Fine Art, 1991.

29

THEODORE J. ROSZAK (1907 – 1981)

30

The Palette, 1930

oil on canvas

15¹³⁄₁₆ × 20¼ in.

(40.4 × 51.5 cm)

inscribed on reverse to

right of monogram: *R30*

A highly innovative artist who worked in a variety of media, Theodore Roszak drew upon a wide range of disparate interests – from technology and machine aesthetics to cosmology and music – for his art. Born in Poland but raised in Chicago, Roszak began evening classes in painting at the Art Institute of Chicago in 1922. About 1925 he enrolled there as a full-time day student, but he left a year later to study painting with Charles Hawthorne at the National Academy of Design in New York. The artist also studied privately with the realist George Luks, whom he considered, along with George Bellows and Leon Kroll, to represent the American vanguard. In 1927 Roszak resumed studies in painting and lithography at the Art Institute of Chicago, and he began to teach there in 1928. On a fellowship, he moved in 1929 to Europe, where he studied modern art and architecture for two years. As he traveled in Austria, Czechoslovakia, France, Germany, and Italy, he became intrigued by the Cubism of Picasso and Léger; the biomorphism of Miró; and the Surrealism of Georgio de Chirico. Later Roszak became engrossed in Constructivism and in Bauhaus aesthetics. All of these movements dramatically affected not only Roszak's style of painting but also his philosophical approach to art. After his return to New York, he worked in the Easel and Mural divisions of the WPA, and he also taught design and composition from 1938 to 1940 at the Design Laboratory, an experimental school based on the principles and methods of the Bauhaus. Roszak built aircraft and taught mechanics – work sympathetic to the tenets of Constructivism – at the Brewster Aircraft Corporation from 1940 to 1945.

During the 1920s, Roszak worked in a romantic, semirealistic style influenced by folk art. However, his study of a broad spectrum of current international movements prompted him to explore several modernist styles within his favored subjects of still lifes, landscapes, and figures. Both Cubism and the Surrealism of de Chirico provided the initial impetus for Roszak to discard his earlier style and to investigate the concerns and inventions of modern art.

Although *The Palette* does not represent the better-known phases of Roszak's oeuvre, it does mark his early adaptation of several cubist elements. Painted quite early in his career and while he was still in Europe, *The Palette* is composed of variously textured and colored shapes that overlap and fracture the motif in a manner reminiscent of cubist collages. Emerging from a dark background and somber colors, the curvilinear shape of the palette and its prominent thumbhole at first evoke the image of a guitar, a frequent motif in cubist collages. The inclusion of artist's tools such as paintbrushes and pigments helps to identify the subject as a palette. This painting may also denote the beginning of Roszak's positivistic belief in science and technology. The composition intuitively rather than literally recalls the machine aesthetics of the Bauhaus. Roszak's depiction of the palette as a machinelike object consisting of individual yet related parts may reflect Bauhaus ideology; he concurred that artists were potential molders of modern, industrial society, and he warmly embraced technology as a means for bringing balance and harmony to that society. Thus, Roszak may have viewed the palette and its mechanization not only as a metaphor for the artist's social role as a creative figure bringing order to society, but also as the means to attain this integration.

Soon after Roszak's return to America in 1931, he began making sculpture, and by 1936 he was constructing pristine, machinelike objects inspired by both constructivist and Bauhaus aesthetics. However, he eventually broke with the ideologies of both movements, coming to believe that the artist is, in actuality, alienated from society and must find inspiration in nature and in introspection rather than from a technological world.[1] Thus, in the mid 1940s an emotionalism began to emerge in Roszak's sculpture through disquieting, expressive images made of mottled, textured surfaces that he achieved through welding. Apart from a series of imaginative abstractions inclined toward archetypal imagery that he painted during the late 1960s and early 1970s, Roszak focused on surrealist, organic sculpture for the remainder of his career.

Note

1 *Current Biography Yearbook* (1966), Charles Moritz, ed., p. 341. New York: H. W. Wilson Company, 1966.

Selected References

Arnason, H. H. *Theodore Roszak* (exh. cat.). Minneapolis: Walker Art Center, 1956.

*Dreishpoon, Douglas. *Theodore Roszak: Paintings and Drawings from the Thirties* (exh. cat.). New York: Hirschl and Adler Galleries, 1989.

Marter, Joan. "Theodore Roszak," in *Lane and Larsen,* pp. 211 – 13.

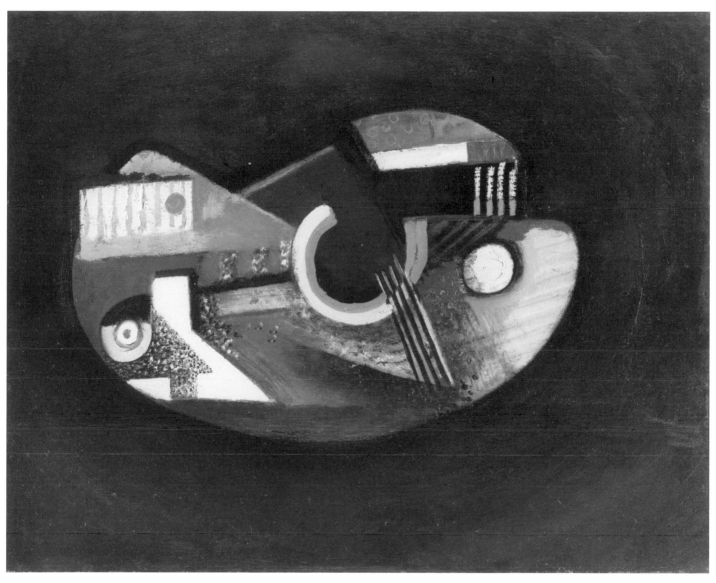

LOUIS SCHANKER (1903 – 1981)

31

Football, 1938

oil on canvas

28¾ × 37¼ in.

(73 × 90.9 cm)

signed and dated

at lower left: *Schanker '38*

Louis Schanker was prominent among the painters of the 1930s and 1940s for his advocacy of expressionism in American abstraction. His constant activities as a sculptor and as a printmaker were also reflected in his paintings, both in style and technique. Born in New York, Schanker left school as a teenager to join the circus. After several peripatetic years as a laborer, he settled in New York in 1920, beginning five years of part-time studies at Cooper Union, the Education Alliance, and the Art Students League. Although his earliest works reflect the Social Realism promoted at the league, he experimented with the styles of the School of Paris in the 1920s. Schanker left for Europe in 1931, studied briefly in Paris, and then traveled widely. When he lived in Majorca in 1933, his style became markedly abstract, with a vivid palette and cubist distortions of space.

Soon after Schanker's return from Europe, his work reflected the influences of Georges Rouault and Fernand Léger, with undertones of German Expressionism. Schanker became a member of the Mural Division of the WPA Federal Art Project; among his most important projects were murals for the lobby of the radio station WNYC in New York (1937) and the Science and Health Building at the New York World's Fair (1939). In the mid 1930s, the artist began making woodcuts, which he printed in colors from multiple blocks. In 1935 Schanker also became one of "The Ten," a group of young artists who championed abstraction and publicly protested the preference of the museum establishment for conservative, representational styles. He was also a founding member of the AAA. From 1938 to 1941 Schanker was employed by the Graphic Arts Division of the Federal Art Project, and he became a supervisor for relief printmaking.

From the late 1930s on, he worked simultaneously in painting, printmaking, and carved sculpture, and he found reciprocal influences in subject, style, and technique among these media. *Football* belongs to a series of paintings and prints that Schanker produced in the late 1930s and early 1940s depicting figures engaged in sports. Several oils of this period represent the subject of football, and one four-color woodcut of the same title relates closely to this particular canvas.[1] Schanker transferred to the painting the angular, splintered quality of the lines hewn from the woodblock. Beginning with sketches, he abstracted several figures in action and the shapes between them into a collection of forms floating before a flat, unmodulated field. Although these are essentially simple geometric solids, they hang on a linear superstructure of thick lines. However, like many of Schanker's paintings of the period, this composition is more formal than linear, and it derives from the work of such French Cubists as Albert Gleizes and André Lhote.

Schanker used several technical tricks to vary the quality of the paint on the heavy canvas he favored. He varied a dry-brush technique with passages of thickly applied impasto, and he added grit or sand to the paint in order to achieve a range of textured, tactile surfaces. The artist softened some forms by scraping away paint. Later, he overpainted the ground in a darker shade of gray, thereby isolating some forms and introducing intricacies of overlap and transparency.

During the 1940s, Schanker began teaching printmaking courses at the New School for Social Research, where he briefly shared a studio with Stanley William Hayter's Atelier 17. The thrust of Schanker's teaching and his own work was independence and experimentation, and he attracted and motivated many innovative artists. He held several teaching posts at the New School, the Brooklyn Museum School, and Bard College from the mid 1940s until his retirement. In the 1950s Schanker became very active with printmaking associations, exhibiting prints which focused on abstract circular forms and which employed shape and color to express a kinesthetic sense of revolution. In the following decade Schanker returned to sculpture, carving freestanding pieces from wood and plastic; in the 1970s he also experimented with relief prints from carved lucite plates.

DA

Note

1 The woodblock *Football* is listed in Johnson (no. 39).

Selected References

Johnson, Una E. *The Woodblock Color Prints of Louis Schanker* (exh. cat.). Brooklyn, New York: Brooklyn Museum, 1943.

Schanker, Louis. "The Ides of Art: Eleven Graphic Artists Write," *Tiger's Eye,* vol. 8 (June 1949), pp. 45–47.

Yeh, Susan Fillin. *Louis Schanker: Works of the 1930s and 1940s* (exh. cat.). New York: Martin Diamond Fine Arts, 1981.

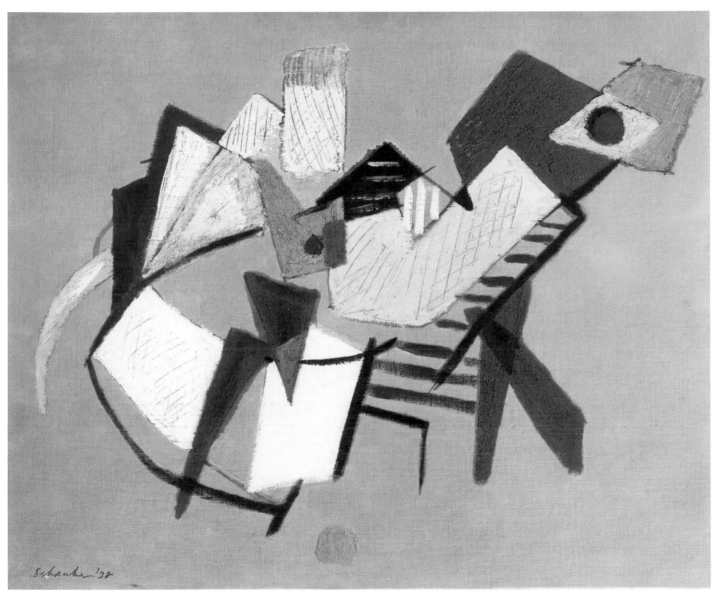

31

32

Composition, 1938

oil on canvas board

18½ × 12½ in.

(47 × 31.8 cm)

signed and dated at

lower center: *John*

Sennhauser/1938

inscribed on reverse:

COMPOSITION/by/

John Sennhauser/218 E.

12 St./N. Y. C.

Arriving at an abstract style in the latter half of the 1930s, John Sennhauser was one of a select group of American abstract painters to come into the circle of Hilla Rebay, the influential director of the Museum of Non-objective Painting. Born in Switzerland, Sennhauser was raised in Italy, where he studied medieval and Renaissance art at the Royal Academy in Venice between 1926 and 1927. In 1928 he moved to New York City, where he worked as an architectural draftsman. Studying at Cooper Union from 1930 to 1933, he developed an understanding of abstract painting. He painted murals on private commission while he taught at the Leonardo da Vinci Art School (1936–1939) and at the Contemporary School of Art (1939–1942).

Not until the 1940s did Sennhauser join vanguard art circles and begin exhibiting nonobjective compositions. In 1943 he joined the staff of the Museum of Non-objective Painting as lecturer, preparator, and assistant to the director, Hilla Rebay; fellow abstractionist and AAA member Jean Xceron was already working at the museum. There, in keeping with Rebay's beliefs, Sennhauser developed an appreciation for the style and mysticism of Kandinsky and for the universal expressiveness of nonobjective art. In 1945 Sennhauser broke with Rebay, having become discontent with her dogmatic philosophy, and he joined the AAA, with which he exhibited in annual exhibitions until the late 1970s. In 1949 he was elected secretary and treasurer of the group, and he served in these capacities until 1952.

Upon his arrival in the United States in 1928, Sennhauser painted romantic depictions of urban street life and interiors. However, in the mid 1930s he also began to explore pure geometric form. *Composition* dates from Sennhauser's early explorations of an abstract aesthetic. It is representative of his more densely compacted, interwoven arrangements of this period, compositions in which brightly colored, opaque nonobjective forms emanate from the center and suggest dynamic rhythms abstracted from nature.

During the late 1930s and the 1940s Sennhauser, in response to his study of the work of Kandinsky during his years at the Museum of Non-objective Painting, developed a brighter palette and a more open, expansive composition enhanced by calli-

graphic and geometric elements. About 1947 color shapes again predominated Sennhauser's work, but they had become jagged and frenzied in rhythm. He continued to use an abstract vocabulary until the late 1950s, when he returned to figurative themes, which he painted in a style influenced by Abstract Expressionism.

Selected References

John Sennhauser: A Retrospective 1937–1950 (exh. cat.). Chicago: Struve Gallery, 1988.
Mecklenburg. *Frost Collection,* pp. 159–61.

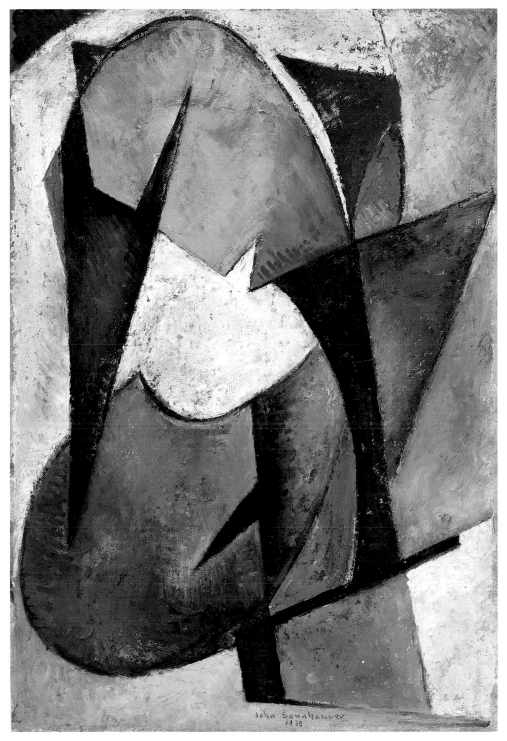

33

Trapezoids, 1936

oil and sand on canvas

36⅛ × 28⅝ in.

(91.7 × 72.5 cm)

inscribed on reverse:

TOP/Shaw/Aug. 1936

Involved in many different careers, Charles Green Shaw was an affluent gentleman who took up painting in his late thirties. His social status set him apart from many of his fellow AAA members and placed him within the circle of so-called "Park Avenue Cubists," which included Suzy Frelinghuysen, Albert E. Gallatin, and George L. K. Morris. After graduation from Yale University in 1914, Shaw completed a year of architectural studies at Columbia University before embarking on a short-lived career in business. Following service in World War I, he worked in New York as a novelist and a free-lance journalist, chronicling prestigious social gatherings in New York, London, and Paris for such magazines as *Smart Set, Vanity Fair,* and the *New Yorker.* His circle of friends included such celebrities as Cole Porter, F. Scott Fitzgerald, and theater critic George Jean Nathan. He became increasingly interested in art in about 1926 and studied at the Art Students League with Thomas Hart Benton and privately with George Luks. In 1929 Shaw made his first of many trips to Europe. During an excursion to Paris in 1932 he visited museums and galleries and was particularly impressed by the work of Cézanne and Picasso. Gallatin exhibited Shaw's work at the Museum of Living Art in 1935, and in 1936 included his work with that of Charles Biederman, Alexander Calder, John Ferren, and George L. K. Morris in the exhibition *Five Contemporary American Concretionists* at the Paul Reinhardt Galleries. Shaw categorized his early art as *concrete* rather than *abstract;* like many of his fellow AAA members, he struggled to find adequate terminology to describe his art.[1]

Having absorbed major developments of the international avant-garde during his European trips in the 1920s and 1930s, Shaw progressed from a cubist manner to a simplified, nonobjective style of pure geometry. During the mid and late 1930s he created an important series of works reflecting this later manner; entitled *Plastic Polygon,* these helped establish his reputation in the New York art scene. Shaw worked in different media and with various forms within this series, from painted wood reliefs that recalled the playful biomorphism of Jean Arp to shaped canvases that physically echoed the architectural skyline of Manhattan.

Trapezoids reflects the strong architectural bent of the *Plastic Polygon* series. Its clearly articulated, geometric forms, which ascend in intervals, mimic the different heights and widths of buildings. In spite of the flat, gray background, Shaw conveyed a sense of spatial recession essentially through two means: the overlap of the trapezoidal forms that cluster together at the center of the composition and the placement of the diagonal edges of the trapezoids. Spare but elegant in its delicate balance and its limited, refined palette, the composition is enlivened by the interplay of hue and of values from opposing sides of the arrangement and through the repetition of similar shapes. Trapezoids of different colors intersect in an arbitrary hue instead of the colors blending where they overlap. The artist also expanded his palette by mixing sand with his oils – a device he initiated in this series – in order to create contrasts between textured passages and flatly painted areas.

Beginning in the 1940s Shaw turned from these architecturally inspired images to a broader, more gestural style and a subtly modulated palette.[2] During the late 1960s he developed bolder, simplified compositions containing a few dynamic, hard-edged elements; these works illustrated his strong graphic sensibility and reflected his admiration for work by Ellsworth Kelly and Frank Stella.

Notes

1 An articulate writer, Shaw promoted abstract art in the yearbooks of the AAA and in other essays. He also served on the advisory board of the Museum of Modern Art during the years 1936 and 1941, and criticized the museum for not collecting art that reflected modern tendencies.

2 Beginning early in his artistic career, Shaw created montages that were never exhibited during his lifetime; these were composed of paraphernalia associated with the gaming room. For a discussion of Shaw's montages, see Susan C. Larsen, "Through the Looking Glass with Charles Shaw," *Arts Magazine,* vol. 51, no. 4 (Dec. 1976), pp. 80–82.

Selected References

Larsen, Susan C. "Charles Shaw," in *Lane and Larsen,* pp. 218–20.

*Mecklenburg. *Frost Collection,* pp. 162–66.

Pennington, Buck. "The 'Floating World' in the Twenties: The Jazz Age and Charles Green Shaw," *Archives of American Art Journal,* vol. 20, no. 4 (1980), pp. 17–24.

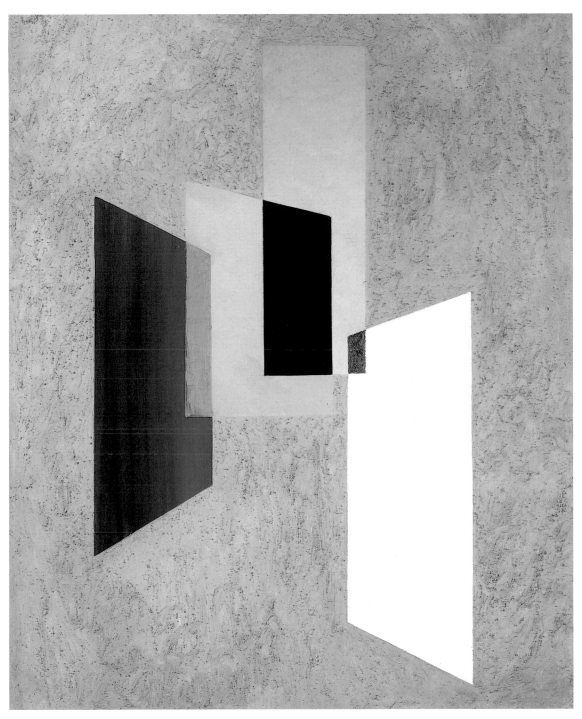

33

ESPHYR SLOBODKINA (born 1908)

34

Red Line, 1938–1939

oil on masonite

23 × 37¹⁵/₁₆ in.

(58.5 × 96.4 cm)

signed in upper right

margin in a vertical

column: *ESPHYR*

SLOBODKINA

inscribed on reverse:

Esphyr/Slobodkina/

108 E. 60

A high-spirited, articulate artist and a devoted member, officer, and chronicler of the AAA, Esphyr Slobodkina actively helped carry the banner of abstraction during the domination of Social Realism and regionalism in the 1930s and early 1940s. Born in Siberia and raised in Harbin in central Manchuria in the aftermath of the Russian Revolution, Slobodkina settled in New York City with her family in 1928. The following year she enrolled in the National Academy of Design, where she met fellow Russian emigré Ilya Bolotowsky, who became her most important teacher and also, in 1933, her first husband.[1] During the early 1930s they developed close friendships with many New York abstract artists, including Gertrude and Balcomb Greene, Alice Trumbull Mason, and Ibram Lassaw, all of whom would help found the AAA. Slobodkina joined the WPA Federal Art Project in 1936, and she was an active member of the Artists' Union. Her longtime association with the AAA began in 1937, shortly before her participation in the first exhibition of this group.

Red Line dates from the period in which Slobodkina's abstract style achieved a sense of maturity. In the mid 1930s her vision evolved out of a free interpretation of cubist form and space and from an assimilation of the abstract idiom of Arp and Miró, but without the anthropomorphic or psychological overtones of their Surrealism. Slobodkina's basic vocabulary of irregular geometric shapes articulated in broad, flat planes of unmodulated color and arranged asymmetrically across the canvas was explored at one time or another during the 1930s by several AAA artists, including Bolotowsky and Gertrude and Balcomb Greene. However, though all of these artists turned to other artistic languages, Slobodkina explored this mode more fully in both paintings and reliefs in the 1940s and beyond.

Red Line is a lyrical composition achieved intuitively through the balance of weight implied by color and shape. The intuitive nature of Slobodkina's working method is underscored by the pentimenti of raised outlines, which reveal shapes she painted out in favor of the current arrangement. Depicted in the artist's favored palette of grays and tans, the design is enlivened by a zigzag of red, which is acknowledged in the title as the subject of the painting.

Throughout her career, Slobodkina supported herself as a noted illustrator of children's books and as a designer of textiles, jewelry, and furniture. She has continued to work in abstraction as a painter, sculptor, and collagist. In the late 1970s she moved to Florida. Her more recent sculptures are whimsical constructions of found objects, often machine parts, and she frequently paints in a manner strongly reminiscent of her abstraction of the 1930s and 1940s.

SES

Note

1 Slobodkina and Bolotowsky were divorced in 1937.

Selected References

Slobodkina, Esphyr. *American Abstract Artists.* Great Neck, N.Y.: privately printed, 1979.

———. *Notes for a Biographer.* Great Neck, N.Y.: privately printed, 1978.

34

35

Untitled, 1946

gouache and graphite

on paper

image: 9¼ × 10¾ in.

(23.5 × 27.4 cm)

sheet: 13½ × 16¾ in.

(34.4 × 42.6 cm)

signed and dated in ball-

point pen at lower right:

SWINDEN–46

Although he was at the center of activity in forming the AAA and was greatly respected by his colleagues for his sensitivity to color, Albert Swinden has remained relatively unknown to the general public owing to his reserved nature and quiet disposition. Born about 1901 in Birmingham, England, he moved to Chicago at the age of eighteen, after having spent several years in Canada.[1] Initially, he studied at the Art Institute of Chicago and at the John Wicker School of Fine Arts in Detroit, and then he moved to New York in order to learn lithography. There, he studied at the National Academy of Design in the mid 1920s and at the Art Students League from 1930 to 1934.[2] Swinden had begun to paint abstract compositions by 1928, and within the next decade his style progressed from a personal idiom based on Synthetic Cubism to one that combined biomorphism and geometry. This development was due no doubt in part to Hans Hofmann's having begun to teach at the league in 1932; Swinden was encouraged by Hofmann's lessons to explore modernist styles. Fellow students at the league included Swinden's friends Burgoyne Diller and Harry Holtzman; all three not only joined the AAA, but they also shared an attraction to Neoplasticism, the style for which they became best known during the 1940s.

One of the founding members of the AAA and its secretary in 1939, Swinden offered the loft he shared with Balcomb Greene for many of the initial organizational meetings. The meetings were moved after a fire destroyed the studio and its contents in about 1941. A participant in several annual exhibitions by the group, Swinden came in contact with many of his contemporaries while working for the Mural Division of the WPA Federal Art Project; he painted murals for the Williamsburg Housing Project (1938–1939) and for the Chilean Pavilion at the New York World's Fair (1939–1940).

Untitled, with its clearly articulated, hard-edged forms and complex tonal range, is characteristic of Swinden's mature style of Neoplasticism in the late 1940s and 1950s. It illustrates his control over the medium and his concern with tonal harmonies and the relationships among forms. Swinden deviated from Mondrian's strict use of primary colors and perpendicular elements, enlivening the rhythms of his work by injecting curvilinear lines and diagonals into the grid. He also created patterns of movement throughout the surface of the gouache rather than working with multiple planes receding into space.[3] As a result, strong lateral movements on the surface of *Untitled* create varying staccato patterns of rhythm and interval.

During the 1950s Swinden began to incorporate the human figure into his otherwise abstract works. Unfortunately, his extant oeuvre is relatively small. Because he disliked promoting his own work, he was diverted from painting by other jobs, such as drafting and textile design, in order to make a living. Furthermore, much of his early work was destroyed in the studio fire.

Notes

1 The exact year of Swinden's birth is unknown; it has been listed both as 1899 and as 1901.
2 He also attended the Beaux-Arts Institute and the Metropolitan Art School, both in New York.
3 Larsen, "The American Abstract Artists Group," p. 112.

Selected References

*Larsen, Susan C. "Albert Swinden," in *Lane and Larsen,* pp. 229–30.

————. "The American Abstract Artists Group: A History and Evaluation of Its Impact Upon American Art" (Ph.D. diss.). Evanston, Ill.: Northwestern University, 1975.

36

Untitled, 1938

oil on canvas

28 × 36 in.

(71.1 × 91.4 cm)

inscribed on reverse:

TOP/R. D. Turnbull/1938

inscribed on stretcher:

G19958

Although Rupert Davidson Turnbull was a founding member of the AAA and was fondly remembered by many of his colleagues, his life and work have remained relatively obscure. Born in East Orange, New Jersey, he studied at the Art Students League in New York and at the Académie Scandinave and the Académie Lhote in Paris. While traveling in France and Italy during the 1920s, he studied with fellow American Vaclav Vytlacil.[1] In 1934, after their European sojourns, they wrote a book together on tempera techniques, and Turnbull lectured at the Art Students League during Vytlacil's tenure as a teacher there. During the 1930s Turnbull taught in New York City, at Cooper Union and at the WPA Design Laboratory.[2] He participated in the early discussions of the AAA, served as its secretary and chairman in the late 1930s, and continued to exhibit with the group until 1942.[3] Albert E. Gallatin purchased one of Turnbull's paintings for the Gallery of Living Art at New York University. According to Balcomb Greene, Turnbull was killed when he fell out of a jeep during World War II.[4]

Turnbull began painting abstractly around 1930. Judging from this untitled oil, he seems to have worked in the late 1930s in a surrealist manner that emanated from the unconscious, which set him apart from the many AAA members who favored hard-edged geometric styles. However, the fluid anthropomorphism and calligraphic brushwork of this painting suggest Turnbull's affinity for the work of Kandinsky and Miró, who were also important influences on many other AAA colleagues. *Untitled* was illustrated in the AAA yearbook of 1946. Few of Turnbull's paintings are known today.

Notes

1 It may be speculated that Turnbull and Vytlacil first met as students at the Art Students League between 1913 and 1916; Turnbull would have been a young student in his midteens.

2 AAA colleague Irene Rice Pereira also worked at the Design Laboratory during the 1930s.

3 On page 615 of *Notes for a Biographer* (Great Neck, N.Y.: privately printed, 1978), Esphyr Slobodkina dates Turnbull's chairmanship to 1940; elsewhere in the manuscript Slobodkina is unclear about when the artist was secretary and chairman.

4 Interview of Balcomb Greene by Susan C. Larsen, Jan. 30, 1973, in Susan C. Larsen, "The American Abstract Artists Group: A History and Evaluation of Its Impact Upon American Art" (Ph.D. diss., Evanston, Ill.: Northwestern University, 1975), p. 529.

Selected Reference

*Mecklenburg. *Frost Collection,* pp. 172–73.

JOHN VON WICHT (1888 – 1970)

37

Untitled, about 1923–1935

watercolor, pen, and

graphite on paper

image: 19³⁄₁₆ × 13⅛ in.

(48.8 × 33.4 cm)

sheet: 20³⁄₁₆ × 14½ in.

(52.4 × 36.8 cm)

signed in ink at lower right:

WICHT

38

Untitled, (from the *Forces*

series), about 1935–1937

gouache and watercolor

on paper

17⅞ × 11⁷⁄₁₆ in.

(45.5 × 29 cm)

signed in ink at lower right:

V. WICHT

inscribed in graphite

on reverse: *#4*

A native of Malente, Germany, John von Wicht was highly trained in the applied arts, and he developed a deep appreciation for the symbolic use of color and shape. Unlike many members of the AAA, he received his art training in Europe. His artistic career began in 1905 with an apprenticeship at a painting and decorating shop; there, he saw painters create beautiful abstract patterns as they sampled colors and cleaned their brushes by wiping them on a wall. Von Wicht later credited this experience as being instrumental in heightening his sense of color and texture. About 1908 he attended the private art school of the grand duke of Hesse, where he was encouraged to draw plants and flowers in order to learn about structure, shape, and proportion. He learned printmaking techniques at the Royal School for Fine and Applied Arts in Berlin, but he frequently skipped class to view exhibitions of work by Cézanne, Gauguin, Kandinsky, Franz Marc, Edvard Munch, and van Gogh; their use of non-naturalistic color intrigued him. In 1923 he decided to leave postwar Berlin for New York, where he worked in color lithography and designed stained-glass windows and abstract mosaics and murals, both commercially and under the WPA Federal Art Project. As a result of these experiences, he began to think about the symbolic and emotive effects of color rather than its naturalistic use, and he began to explore these issues in early abstractions.

Von Wicht believed that a simpler and stronger work of art could be achieved by abstracting the colors and forms of nature. Between about 1923 and 1935 he executed nonobjective compositions of simple geometric forms and lines. Dating from this early period, the untitled watercolor shown here draws upon Kandinsky's Bauhaus geometry of basic shapes floating in an undefined setting. Working in an acidic palette and exploiting the inherently luminous properties of watercolors, von Wicht also explored the perceptual and emotive effects of transparency and the juxtaposition of colors in combination with the balance of forms.

Between 1935 and 1937 von Wicht painted *Forces,* a group of related works composed of dense areas of color and severe geometric and linear forms.[1] The untitled gouache included here belongs to this series, and it builds upon von Wicht's basic geometric vocabulary, but in a more animated, compacted design. The sense of inherent dynamism

implied by the title of the series is conveyed through diagonal thrusts compressed within a shallow space and through the artist's broad modeling of form. In 1941 von Wicht exhibited another painting from the *Forces* series at the Whitney Museum of American Art. The work brought him much public recognition, and he was invited to join the AAA.[2]

After World War II von Wicht, inspired by his experiences as captain of a supply barge, painted abstractions based on nautical themes. Later in his career he composed expansive, calligraphic abstractions in a brilliant, luminous palette. He continued to paint loose, expressionistic works until his death in 1970.

Notes

1 The heavy black outlines delineating the intersecting shapes evoke the mullions of stained-glass windows that von Wicht had designed in the 1920s and 1930s.

2 Von Wicht, n.p.

Selected Reference

John von Wicht. "Recollections," Sept. 14, 1957. John von Wicht Papers, Archives of American Art, Smithsonian Institution, Washington, D.C.

37

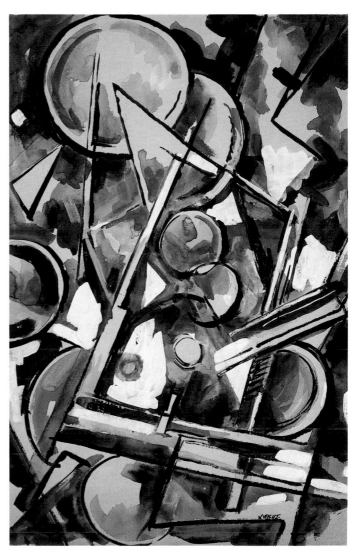

38

39

White, Red and Blue Planes, 1952

gouache and graphite on matte board

13 × 13 in.

(33 × 33 cm)

signed at center of bottom margin: *CVW*

Primarily known for her supportive articles and reviews on abstract art, Charmion von Wiegand was one of the few artists working in a neoplasticist idiom who knew Piet Mondrian. Although she did not have any formal training in studio art, von Wiegand was keenly aware of the New York art scene as a journalist, and she joined the AAA in 1941.[2] Her career as an artist may have been delayed because her father wanted her to follow him into a career in journalism. She attended the Columbia School of Journalism, but transferred to Columbia and New York universities to study theater, art history, and archaeology. She began to paint in 1926 as a result of her psychoanalysis, but did not consider herself to be a professional artist until 1947, when she had her first show. From 1920 to the 1940s she combined journalism with her interest in the arts. She worked primarily in Moscow as a foreign correspondent and in New York as an art critic for the *New Masses,* an important leftist journal, and as art editor for *Art Front,* the official publication of the Artists' Union. She also arranged publicity for the Federal Art Project. Her paintings during this period were primarily semirealistic landscapes. However, she began to work in a nonobjective style after interviewing Mondrian in 1941 for an article about European artists who had come to New York to escape Fascism.[3] Von Wiegand studied Mondrian's paintings while translating his writings into English; this study and her extensive research of Neoplasticism resulted in her understanding of and fascination with the spiritual and philosophical aspects of the movement.[4]

Deceptively simple, *White, Red and Blue Planes* is actually a thoughtful, complex arrangement of color and plane whose compositional format and use of primary colors with black and white derive from Neoplasticism. Like Mondrian, von Wiegand emphasized the two-dimensional tensions that resulted from the location, size, and unmodulated color of the rectangles and squares. The clearly defined rectilinear elements do not recede deeply into space; instead, they create lateral surface movement. Many of her paintings of the 1940s and 1950s do not adhere as rigidly as *White, Red and Blue Planes* does to the strict neoplasticist format, but, rather, vary in palette and compositional orientation and movement. During the 1950s the artist deviated from Neoplasticism and concentrated on

making collages, which she had begun to explore in 1946 and whose inspiration lay with the German Dadaists Hans Richter and Kurt Schwitters. Around 1949 von Wiegand became interested in Tibetan Buddhist art and philosophy, and began to include in her paintings and collages motifs based on Eastern religious symbols.

Although she had reviewed the first exhibition of the AAA in 1937 for the *New Masses,* von Wiegand did not join the group until about 1941, when Mondrian and Carl Holty encouraged her to do so. She remained an associate member until 1944, rejoined in 1947, and exhibited with the group until 1966. She served as its president between 1951 and 1953.

Notes

1 Though she was born in Chicago, von Wiegand's exact date of birth is unknown; it has been listed variously as 1896 and 1899.

2 John Graham, Jules Pascin, and Joseph Stella offered von Wiegand friendly advice on her work, although she never studied with any of them.

3 Charlotte Streifer Rubinstein, *American Women Artists: From Early Indian Times to the Present* (New York: Avon Books, 1982), p. 296.

4 She was already familiar with Mondrian's work in Gallatin's Museum of Living Art, but had initially thought it was overly mathematical. In 1943 she wrote the first critical article on Mondrian to be published in America (Troy, p. 56).

Selected References

*Hill, May Brawley. *Three American Purists: Mason, Miles, Von Wiegand* (exh. cat.). Hartford, Conn.: Fox Press, 1975.

Larsen, Susan C. "Charmion von Wiegand: Walking on a Road with Milestones," *Arts Magazine,* vol. 60 (Nov. 1985), pp. 29–31.

Mecklenburg. *Frost Collection,* pp. 176–78.

Troy, Nancy J. *Mondrian and Neoplasticism in America* (exh. cat.). New Haven, Conn.: Yale University Art Gallery, 1979.

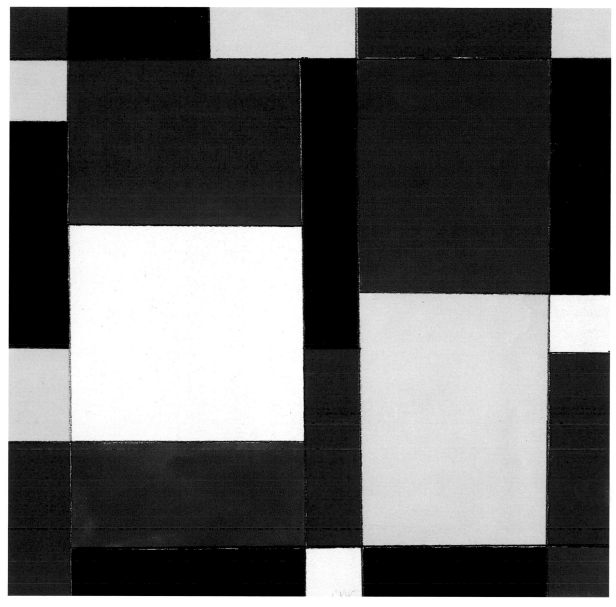

39

VACLAV VYTLACIL (1892 – 1984)

40

Untitled, 1939

oil on academy board

13⅝ × 17½ in.

(34.6 × 44.5 cm)

signed and dated at lower

right: *Vaclav Vytlacil 1939*

Vaclav Vytlacil traveled abroad purposely to seek out the European manner that became the foundation of the second wave of American abstraction. Among the first and most influential proponents of Hans Hofmann's teachings in the United States, Vytlacil passed on these ideas and techniques to a generation of American abstractionists through a long teaching career of his own.

Born in New York of Czechoslovakian parents, he moved as a boy with his family to Chicago. In his teens he began his studies at the Art Institute, and his proclivity as a draftsman won him a scholarship to the Art Students League in New York. There, beginning in 1913, he was the student of John C. Johansen, a fashionable portraitist who worked in an impressionist style. From 1916 until 1921 Vytlacil taught this style of painting at the Minneapolis School of Art; yet, even then, he was inclined toward European modernism. The artist saved methodically so he could move to Europe to study Cézanne and steep himself in the works of the old masters.

Vytlacil arrived in Paris in 1921. After a few months, he decided to stay in Munich, where he met Hans Hofmann, at that time a little-known German painter who had just opened his own academy. In 1923 Vytlacil joined Hofmann's classes, and from that point on the young American worked in an abstract mode that reflected an understanding of Cézanne's style as it had been gleaned largely from Hofmann. Reconsidering his own aesthetic preconceptions and artistic process, Vytlacil recognized the rudimentary importance of drawing, and found a wholly new approach to color.

He had begun to develop a successful career in Europe when he accepted an invitation during the summer of 1928 from the University of California at Berkeley to lecture on modern European painting and sculpture. In the fall he visited New York, serving briefly as an instructor at the Art Students League, where he encountered opposition from powerful social realist instructors. Nevertheless, Vytlacil's lectures had lasting significance on many young Americans who were lured to modernism by his articulate persuasion. His reputation as a fine teacher was instantly established, for, like Hofmann, Vytlacil taught the philosophy as much as the technique of painting.

In order to experience firsthand the art of Picasso and Matisse, Vytlacil returned to France in 1930.

His landscapes and still lifes from the next six years merged cubist space with an expressive calligraphic sense of line and color. Although the artist often created completely nonobjective images, his works were mostly abstracted from recognizable objects. When Vytlacil finally returned to America in the fall of 1935, he resumed teaching at the Art Students League in New York, and he actively participated in the formation of the AAA.

The subject of this oil study is the spatial and physical effects of the colors themselves. Using humble materials Vytlacil balanced the hues much more carefully than his seemingly haphazard technique evinces. The artist's approach was intuitive, but nevertheless controlled. He often used different tints of the same color, giving the whole composition a buzzing, dynamic quality. In some passages, he overpainted areas several times, adjusting colors and surface effects. Underlying colors show through around the edges of some forms, giving them a rough, organic appearance. Reminiscent of Hofmann's work, Vytlacil's sketch has a handmade, spontaneous quality imparted by the application of paint. The surface texture is enlivened by bits of dirt or globs of dried paint and by passages of active brushwork. This liveliness points to the new freedom that came into Vytlacil's painting during the 1940s. Energy progressively replaced form as the primary focus, and his images gained unprecedented freshness. During the remainder of his career, Vytlacil continued actively painting and exhibiting. He remained devoted to teaching, holding positions across the country. He retired from teaching altogether only three years before his death.

DA

Selected References

Vaclav Vytlacil (exh. cat.). Montclair, New Jersey: Montclair Art Museum, 1975.

*Larsen, Susan C. *An American Modernist: Paintings from the '20s and '30s by Vaclav Vytlacil* (exh. cat.). New York: Graham Gallery, 1988.

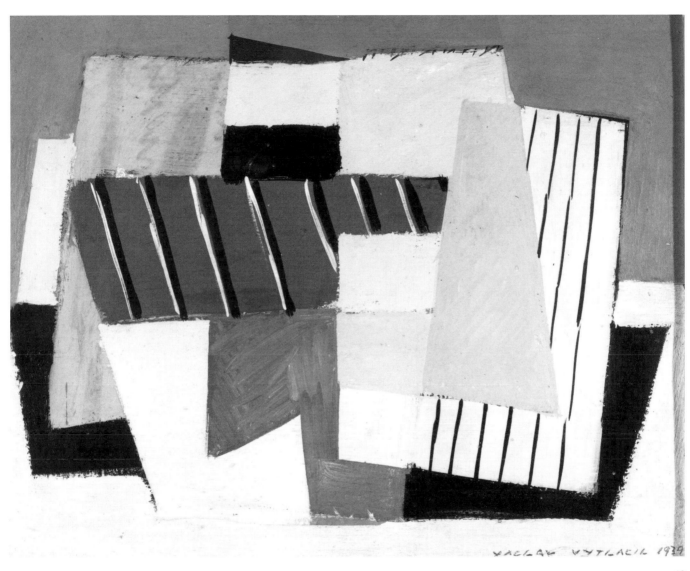

40

41

Still Life with Gin Bottle,

1936

oil on canvas board

23⅞ × 19¾ in.

(60.7 × 50.2 cm)

signed and dated at

lower right:

F. Whiteman/'36

stenciled on reverse:

Whiteman/1936

inscribed on reverse:

20083

One of the few progressive artists from a younger generation to be included in the controversial exhibition *Abstract Art in America* at the Whitney Museum in 1935, Frederick Whiteman adhered to a conservative style based on the late, decorative phases of Cubism. Raised in the small Pennsylvania towns of Punxsutawney and Indiana, which favored cultural programs in music and theater, he independently pursued his interest in the visual arts while he was in high school. At an early age, he began developing drafting skills and a fascination with mechanical and electrical devices largely through the influence of his father, a distributor of railway, mine, and electrical supplies. After working for a time in engineering, he moved to Pittsburgh in order to enter the art program at the Carnegie Institute of Technology, and from 1929 to 1930 he also studied with Alexander J. Kostellow, who, in turn, had been influenced by Jan Matulka and Vaclav Vytlacil.[1]

Between 1930 and 1932 Whiteman studied painting with the modernist Jan Matulka and etching and lithography at the Art Students League in New York.[2] During the 1930s, Whiteman worked as a commercial artist in various advertising agencies and began to teach privately. He was a founding member of the AAA and was employed by the WPA Federal Art Project as a teacher and an administrator. From 1937 to 1939, he served as director of the WPA art centers in Greensboro, North Carolina, and Greenwich, Mississippi. Upon his return to New York about 1939, he joined the staff of the Pratt Institute as an instructor and an administrator, positions he held until his retirement in 1974. He also attended classes at that institution between 1954 and 1958 in order to further his own education and to determine the relevance of the general studies courses for art students there.

By the 1930s Whiteman had already progressed from a pictorial, illustrative mode to a highly stylized, hard-edged manner that reflected his understanding of the spatial concepts of Cubism. Fueled by his childhood interests in electrical and mechanical gadgets and in precision instruments, Whiteman analyzed form in terms of structure, space, and color. Recently recalling his approach to painting in the 1930s, Whiteman likened a successful composition to an efficient machine, noting that "every canvas would be a machine, a single unit with no loose and unnecessary parts — and it should work!"[3]

Whiteman began developing the theme of the gin bottle about 1933 in a series of preparatory drawings and canvases, a practice he often used. Completed three years later, the version shown here is a finished work in which Whiteman abstracted the still-life elements beyond recognition. The integration of the word *GIN* into the overall design is a typical cubist device. In fact, the motif, the flat compositional arrangement, the somber palette, and the inclusion of text all draw upon elements of Synthetic Cubism. However, Whiteman enlivened the design with rhythms suggested by crisp curvilinear contours of broad areas of unmodulated color.

Notes

1 Whiteman, Kostellow, and Donald Dohner planned to establish an art school modeled generally upon Bauhaus principles; there, students would study design and produce commercially viable products. However, the school never advanced beyond its preliminary planning.
2 Whiteman stated that he studied etching and lithography during the Depression, as did artists already better known in New York City, in order to be able to mass produce prints that could be sold in quantity at affordable prices.
3 Letter from Frederick Whiteman to Elaine D. Gustafson, Mar. 1991.

Selected References

Mecklenburg. *Frost Collection,* pp. 186–87.

*Whiteman, Frederick. "Personal History Statement," Curatorial Files, National Museum of American Art, Smithsonian Institution, Washington, D.C.

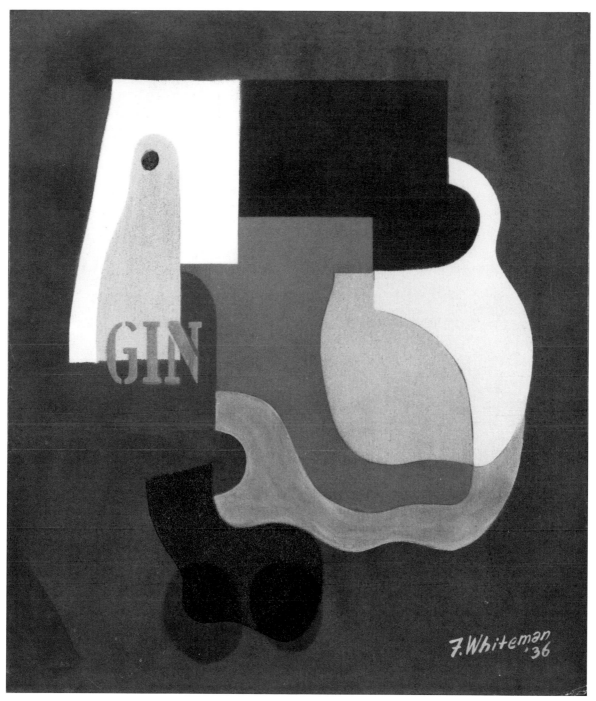

41

JEAN XCERON (1890 – 1967)

42

White and Gray, No. 256,

1941

oil on canvas

32 × 25⅝ in.

(81.2 × 65.1 cm)

signed at lower right:

Xceron

Associated with the inner circle of Abstraction-Création in Paris in the late 1920s and the 1930s, Jean Xceron brought to the AAA his modest international reputation as a painter and his important European contacts. Greek by birth, he immigrated in 1904 to the United States. Settling in Washington, D.C., in 1910, Xceron intermittently attended the Corcoran School of Art until 1917. He first encountered modernism when, in 1916, two fellow students arranged an exhibition of avant-garde paintings from the collection of Alfred Stieglitz.[1] In 1920 Xceron moved to New York and became friendly with three members of the first generation of American modernists: Joseph Stella, Abraham Walkowitz, and Max Weber. Xceron moved to Paris in 1927, where he wrote art criticism and reviews for the Paris edition of the *Chicago Tribune* and the *Boston Evening Transcript*. Through his friendship with Joaquín Torres-García, Xceron met Arp, Jean Hélion, Léger, Mondrian, and Theo van Doesburg. Upon his return to New York about 1937, Xceron was hired by the WPA Federal Art Project to paint an abstract mural for the chapel at Riker's Island Penitentiary, and he joined the AAA, with whom he exhibited between 1940 and 1965. Shortly after Hilla Rebay acquired several of Xceron's paintings for the Solomon R. Guggenheim Foundation in 1939, she offered him a position at the Museum of Non-objective Painting, where he worked until his death in 1967. His association with the dogmatic Rebay, who propounded spiritual and mystical notions of nonobjective art, separated him somewhat from his AAA colleagues, most of whom rejected these ideas.

During the 1920s and early 1930s Xceron's figurative style — which was influenced by his study of Cézanne and Cubism — moved closer toward abstraction. By the mid 1930s Xceron developed a nonobjective, geometric mode inspired by the aesthetics of Neoplasticism and Abstraction-Création. His initial, strict gridlike patterns gave way to softer, planar arrangements that emphasized rhythmic movement of line and form.

White and Gray, No. 256 not only reflects the range of styles that Xceron had absorbed during his years in Paris, but it also indicates his adaptations of them. The overall rectilinear arrangement of rectangles and grid lines strongly recalls elements of Neoplasticism, Suprematism, and Constructivism. Yet Xceron diminished the hard-edged effect of

these geometric manners, creating a lyrical composition in which the forms seem to hover against — and in one instance almost disappear into — a radiant light. Throughout the 1940s, Xceron continued to soften the geometry of his compositions as he had begun to in this painting, and he moved toward more vibrant and varied colors than those of this limited, harmonious palette.

By the early 1940s the artist was also working in an idiom that strongly reflected the Bauhaus aesthetic of Kandinsky and Rudolf Bauer, both of whom were broadly represented in the Museum of Non-objective Painting. During the 1950s and 1960s, Xceron fell under the influence of Abstract Expressionism and color field painting, and he sought ambiguous effects in less geometric, more suggestive works.

Note

1 Impressed by the exhibition, Xceron found encouragement in the flat color and expressive distortion of form in some of the works.

Selected References

Ashton, Dore. *Jean Xceron* (exh. cat.). New York: Camillos Kouras Gallery, 1984.

*Robbins, Daniel. *Jean Xceron* (exh. cat.). New York: The Solomon R. Guggenheim Museum, 1965.

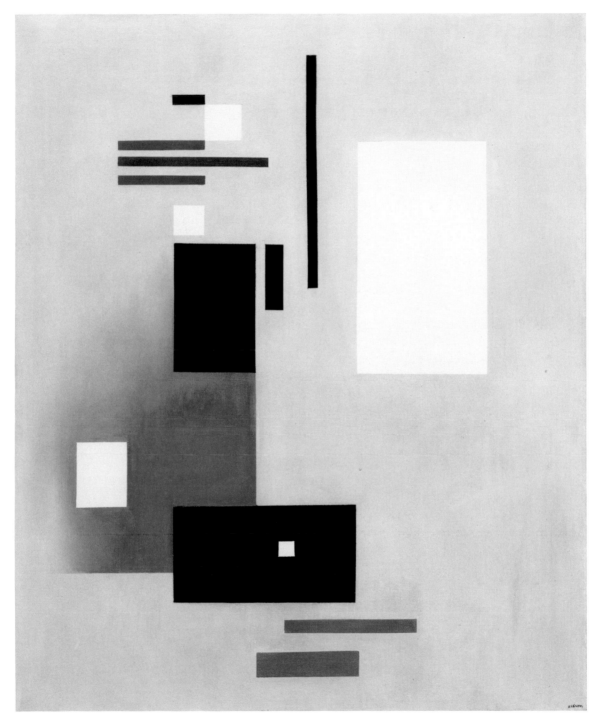

42

WILFRED ZOGBAUM (1915 – 1965)

43

Untitled, about 1935

oil on canvas board

16 × 20 in.

(40.7 × 50.8 cm)

stamped on reverse:

Wilfred M. Zogbaum /

East Hampton, NY

An established and significant member of the AAA and the abstract expressionist groups, Wilfred Zogbaum worked successfully in three media: painting, photography, and sculpture. He first studied painting and drawing as a teenager at the Rhode Island School of Design during the summers of 1932 and 1933. He attended the Yale School of Art for a year, but left in 1934 in order to go to New York, where he studied with the realist John Sloan until 1935. Between 1935 and 1937, Zogbaum served as a class monitor for Hans Hofmann, who exerted a considerable influence on him. Already working in an abstract manner, Zogbaum became a founding member of the AAA in 1937, when he was twenty-two years old. That same year he traveled to Europe on a Guggenheim Fellowship. There, he met such progressive modernists as Calder, the Constructivist Naum Gabo, the Spanish sculptor Julio González, Hélion, Kandinsky, Léger, Moholy-Nagy, and a few lesser-known Bauhaus instructors. Upon his return to the United States about two years later, Zogbaum continued to paint independently until he enlisted in about 1941 in the United States Army Signal Corps as a photographer. From 1946 to 1948 he worked in New York as a high-fashion photographer, but he left this career to devote full time to painting.

Subscribing to Hofmann's belief that artistic inspiration must derive from nature, Zogbaum illustrated in his paintings his conceptual and empirical perception of nature. Zogbaum believed that, in interpreting nature through the creative process, the chosen motif lost its original identity and was fused into a new reality: the work itself. Consequently, in many of his paintings, the visual connection with nature is intuitive rather than literal.

Zogbaum painted the untitled oil illustrated here when he was in his early twenties, possibly during his close association with Hans Hofmann. Zogbaum employed a varied, bright palette; tactile, visible, and thickly layered brushwork; and the repetition of multiple, active, generalized shapes to convey a sense of the energy and rhythms, as well as the structure and colors, of nature. The active brush strokes and surface foreshadow Zogbaum's attraction in the mid 1950s to the gestural and expressive brushwork of Abstract Expressionism. Acquainted

with most of the leading figures of this movement, Zogbaum became a member of "The Club."

Also in the mid 1950s, Zogbaum turned with increasing focus to sculpture as a means of supplementing his painting; by 1956 he was working exclusively in this medium. Continuing his interest in nature, he initially constructed animals and figures from found objects such as beach stones and machine parts, but he progressively worked more abstractly. Between 1957 and 1962 he held short-term teaching positions at the University of California at Berkeley; the University of Minnesota in Minneapolis; Southern Illinois University in Carbondale; and the Pratt Institute in New York.

Selected References

Humphrey, John. *Wilfred Zogbaum: Sculpture 1955–1964* (exh. cat.). San Francisco: San Francisco Museum of Art, 1973.

Mecklenburg. *Frost Collection,* pp. 198–200.

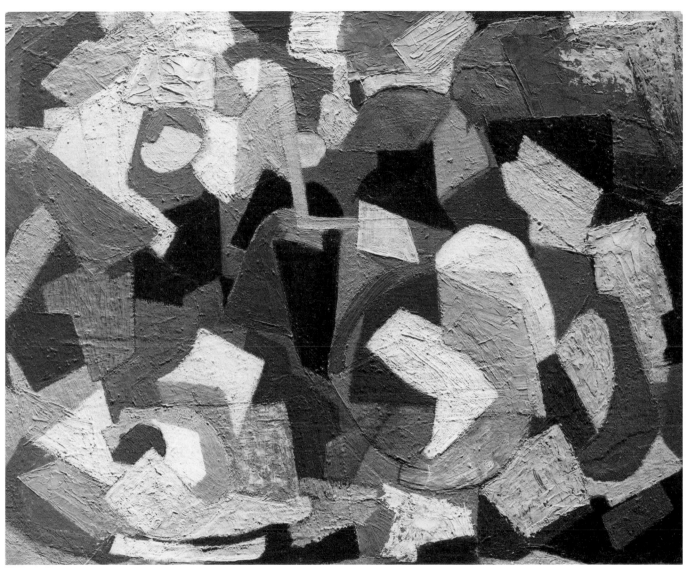

43

All but three of the forty-seven artists in this exhibition belonged at some point in their careers to either the American Abstract Artists (AAA) or the Transcendental Painting Group (TPG). Although many, perhaps even the majority, of the most significant American abstract artists of the 1930s did join together for purposes of exhibiting and promoting their art and for collegial support, others obviously chose not to for various reasons.

Charles Biederman, Rolph Scarlett, and John Storrs all lived and worked in New York City at some time, and they all became well acquainted with their contemporaries who formed the ranks of the AAA. Biederman and especially Storrs were often away from New York City during the formative discussions and activist years of the AAA. Storrs moved to France at the outbreak of World War II in Europe and never returned to the United States, and Biederman remained independent from the AAA because of philosophical and political differences. Biederman left New York in 1941 and settled out of the artistic mainstream in Red Wing, Minnesota. As part of the inner circle surrounding the dominant figure of Hilla Rebay, the director of the Museum of Non-objective Painting, Scarlett espoused the notion of art as the expression of man's spiritual nature, a concept eschewed by many AAA members who periodically clashed with Rebay. Just as the AAA and TPG are representative of the organizations formed in this era by progressive artists, Biederman, Scarlett, and Storrs exemplify many who remained independent of such formal associations. Neither the quality of their art nor the success of their careers seems to have been affected by their independence. Rather, during the past decade almost all of these artists have been rediscovered and their work reexamined by historians and the public alike.

44

Heads, New York, June 1935

oil on canvas

35¹/₁₆ × 26 in.

(89.1 × 66.1 cm)

inscribed on reverse:

Ch. Biederman/6/35

Although Charles Biederman responded to and experimented with many of the same aesthetic stimuli as did his artistic contemporaries, he remained independent of much of the New York art scene and eventually even shunned it. Even though he knew many members of the AAA, Biederman never joined the organization, and, in fact, he rejected its principles and politics. His artistic career began as a layout artist in a commercial design studio, where he worked for four years before attending classes at the Art Institute of Chicago between 1926 and 1929. From 1926 to 1933 he painted landscapes and still lifes that were essentially influenced by Cézanne, whose principles he held in high regard throughout his life.[1] Biederman's first abstract works date from 1934, the same year he moved to New York City. There, he was exposed firsthand to an array of European modern art at museums and galleries. As a result, his next few years were prolific with stylistic experimentation. Attracted particularly to the cubist work of Braque, Picasso, and Léger, as well as to the anthropomorphic Surrealism of Miró, Biederman began to depict in his paintings biomorphic, surrealist, mechanistic, and geometric volumes, sometimes merging the vocabulary of several modes into a single picture.

Heads, New York, June 1935 belongs to Biederman's earliest period of abstraction. In this piece, he has subdued the whimsical biomorphic forms of Surrealism by employing a stricter geometry. However, the overall tone of the work remains playful through the artist's use of decorative color and the underlying anthropomorphic suggestion of a profile. Although the crescent, large dot, and horizontal stripes are depicted as flat, the two pyramids convey a sense of three-dimensional form through the juxtaposition of color and the use of diagonals and modeling. The composition of *Heads* reflects Biederman's lifelong effort to reconcile the disparate elements of two and three dimensionality, a struggle he felt he resolved more fully in his later relief sculptures.

Having grown dissatisfied with the New York art community and its unsympathetic attitude toward abstract art, Biederman moved in 1936 to Paris, where he met major artists working in cubist, constructivist and neoplasticist veins.[2] After meeting Mondrian, Biederman began more vigorously to explore neoplasticist principles; his work became more rectilinear and two-dimensional, stressing primary colors, black, and white. Upon his return from Europe in 1937 he eliminated biomorphic forms from his paintings, seeing the organic and the geometric as conflicting. Believing that neoplasticist painting lacked verisimilitude because it denied the third dimension,[3] Biederman began to translate his paintings into reliefs and freestanding sculptures. Soon thereafter, he abandoned painting and freestanding sculpture in order to concentrate entirely on reliefs, which were initially inspired in their medium by Constructivism and in their style by Neoplasticism. He continues to explore this medium in Red Wing, Minnesota, where he has lived since 1941.

EDG

Notes

1 Other major French artists from Realism to Post-Impressionism periodically influenced Biederman's style.

2 A few of the artists Biederman met in Paris were Arp, Brancusi, Kandinsky, Léger, Mondrian, Pevsner, and Vantongerloo.

3 Philip A. Spahr, "Charles Biederman," in *Beyond the Plane: American Constructions 1930–1965* (exh. cat.), Trenton: New Jersey State Museum, 1983, p. 26.

Selected References

*Sjoberg, Lief. "Charles Biederman's Search for a New Art," in *Charles Biederman: A Retrospective* (exh. cat.). Minneapolis: Minneapolis Institute of Arts, 1976.

Van der Marck, Jan. "Landscapes by Whatever Name," in *Charles Biederman: A Retrospective* (exh. cat.). Minneapolis: Minneapolis Institute of Arts, 1976.

———. "Biederman and the Structurist Direction in Art," in *Charles Biederman* (exh. cat.). London: Arts Council of Great Britain, 1969.

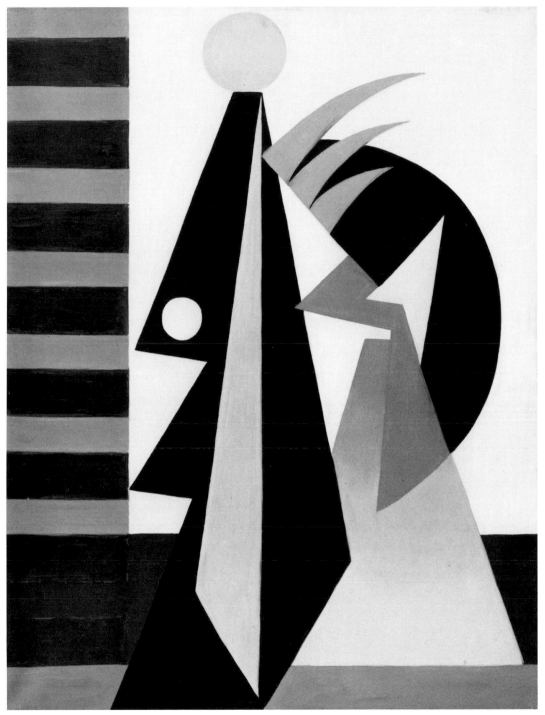

44

ROLPH SCARLETT (1889 – 1984)

45

Upward Motion No. 3,

about 1938

oil on canvas

36 × 36 in.

(91.5 × 91.5 cm)

A champion of the ideals of nonobjective painting, Rolph Scarlett was one of the most accomplished artists who formed an early alliance with Hilla Rebay, the first director of the Museum of Non-objective Painting. Born in Guelph, Ontario, Scarlett was the son of a jeweler, who urged him to follow in the family business. As a teenager he studied briefly at the Loretto Academy while working for his father. In order to gain further experience in jewelry making, Scarlett went to New York in 1907, working there as an apprentice. After World War I, he had a succession of jobs as a commercial designer and a craftsman, and in his spare time he painted ever more avidly. The artist's earliest representational works reveal a tendency to eliminate detail and to reduce compositions to their basic geometric components.

In 1923 Scarlett traveled to Europe; there he was deeply impressed by the work of Paul Klee. After his return, he became more serious about painting. In 1936 he settled in New York City, where he became aware of the sweeping collection of contemporary art then being formed by Irene and Solomon R. Guggenheim, under the guidance of Hilla Rebay. The artist submitted his paintings to Rebay for approval, and attended her lectures and critiques. Rebay gradually influenced Scarlett and exposed him to the works of Kandinsky, Klee, Moholy-Nagy, and Mondrian.

Both Rebay and Scarlett believed that art was the expression of man's spirituality, which had as its basis a fundamental set of beliefs about the nature of the universe. The artist called his painting "non-objective" believing that, rather than being abstracted, its imagery was synthesized to represent specific precepts. Scarlett believed that an artist need not repeat existing forms or compositions, but with the guidance of a god, could envision a fresh and personal vision that expressed natural laws and cosmic forces. Despite these declarations of originality, several influences are apparent in Scarlett's pictures of the 1930s and 1940s. Among them are the works of Klee and Kandinsky, and of Rudolf Bauer, a German painter living in New York who became Scarlett's mentor.

Upward Motion No. 3 exemplifies Scarlett's imagery in its use of the simplest means to achieve pleasing harmonies of color and form, which he meant to symbolize profound themes of the nature of creation. Typically, the artist used basic, two-dimensional geometric figures traced from stencils, wooden blocks, tin cans, and other everyday objects. Against a dull, neutral ground he plotted these brightly colored shapes in a balanced, asymmetrical composition seemingly suspended in an undefined space. Moreover, he created an illusion of depth by the mottled surfaces of the ground and the figures, and by the overlapping of the forms themselves. Some of the long, rodlike forms pass beneath certain shapes and over the tops of others; this effect also suggests some dimension, but it seems as shallow as the depth of collaged paper. The forms are so slight, their edges so crisp and precise that they seem mathematical and crystalline, not organic. The artist did succeed in imparting the suggestion of potential motion, but it seems inexorably slow. The effect of depth and vastness grew in the paintings that Scarlett made after 1940, as his backgrounds became more modulated and seemingly broken by rays of light.

In 1939 Scarlett was able to give up his commercial work and devote himself solely to painting, and he began to exhibit regularly. Between that time and 1952, Rebay acquired sixty of his paintings as well as numerous watercolors, drawings, and monotype prints, for the Guggenheim collection. Thus, the artist's work appeared regularly in group exhibitions at the museum throughout the 1940s, and he was the chief lecturer there for five years during that decade. Rebay came to consider Scarlett one of her most eloquent advocates. He lived out his life in Woodstock, New York, where he designed jewelry, painted, and continued to exhibit his work actively in New York City until the year preceding his death.

DA

Selected References
Gibbs, Josephine. "Rolph Scarlett, Factless Precisionist," *Art Digest,* vol. 18 (Dec. 15, 1943), p. 18.
Lukach, Joan M., "Rolph Scarlett," in *Lane and Larsen,* pp. 214–15.

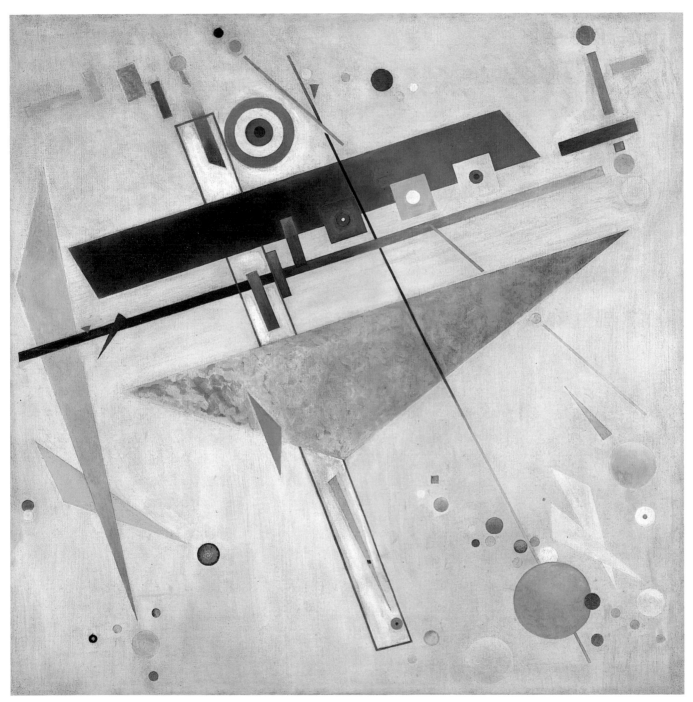

45

JOHN STORRS (1885 – 1956)

46

Conversation, 1931

oil on masonite

17¾ × 12 in.

(45.2 × 30.4 cm)

inscribed on reverse:

STORRS/ 10-12-31

Having had a career that spanned both the first and second waves of American abstraction, John Storrs is best known as one of the first Americans to produce cubist and nonobjective sculpture. His lesser-known career in painting began in 1930. The son of a Chicago architect, Storrs first pursued his creative inclinations about 1900, as a student at the Chicago Manual Training School. From 1905 to 1907, during his first European sojourn, he not only decided to study art seriously, but also developed an affinity for the simplicity, geometric order, symmetry, and sense of unity in current German design and architecture – aesthetic principles that would underscore much of his later work. During the next four years, he studied with Lorado Taft at the Art Institute of Chicago; with Bela Pratt at the Museum of Fine Arts, Boston; and with Charles Grafly at the Pennsylvania Academy of Fine Arts. In 1911, Storrs returned to Paris. There, he studied with the American Beaux-Arts sculptor Paul Bartlett and was befriended by Auguste Rodin, who became an important teacher and mentor. Storrs's earliest work reflected his knowledge of the expressive modeling of Rodin and the massive figures of Aristide Maillol.

About 1915 Storrs emerged as an innovative sculptor, applying a simplified cubist monumentality to monolithic compositions of one or two figures. About 1917, influenced by the dynamics of British Vorticism, he produced his first totally nonobjective sculpture. As the 1920s approached, his work sometimes tended toward the stylized simplification of Art Deco. In the middle of that decade, Storrs created a group of pieces from contrasting metals that reflected the sleek proportions and masses of skyscrapers. He experimented with color in sculpture whether painting terra-cotta, combining various stones, or juxtaposing different metals. As an able sculptor responding to a variety of influences, Storrs received some critical acclaim in the mid 1920s, as well as a few commissions to produce works on a monumental scale.[1]

However, in late 1930, at the age of forty-five, Storrs turned to painting probably out of the necessity to support his family in the face of the Depression, the scant sales of his sculpture, and the lack of major commissions. He had studied painting during his earliest years at art school. His canvases of the early 1930s were nonobjective, and they directly reflected the monumental architectural

volumes of his sculpture of this same period. In a number of these early paintings, Storrs built the composition around the juxtaposition of a few simple elements. In *Conversation* the two dominant central forms seem to engage in a human embrace, underscoring a metaphor that the artist himself articulated in the title. The opposition of the purely compositional elements of form and void – enhanced by distinct contrasts in color – suggests the universal tensions between man and woman. In composition, motif, and theme this painting relates to one of Storrs's most famous steel sculptures of the 1930s, *Composition Around Two Voids* (1934, Whitney Museum of American Art).

Though Storrs worked for the Public Works of Art Project in 1934, he remained relatively independent from the circle of artists who formed the AAA, and he never joined the group. In part this may have stemmed from his age, his frequent absence from New York during visits to Paris and Chicago, and his final departure for France in 1939. Storrs never returned to the United States after the outbreak of war in Europe. His physical, emotional, and creative energies were sapped by two terms of internment stemming from accusations that he sympathized with the French resistance. Although he continued to paint and to sculpt, his style in the mid and late 1930s became more organic. After the war he turned to a more realistic mode, frequently combining a psychologically penetrating vision of his figurative subjects with a generalized style related to Art Deco.

SES

Note

1 Among Storrs's major commissions were: the statue *Ceres* on top of the Board of Trade Building in Chicago (1928); reliefs on the United States Naval Monument (destroyed in the war) in Brest, France (1929); a sculptural program for Church of Christ the King in Cork, Ireland (1929); and various works for *A Century of Progress* at the Chicago World's Fair (1932–1933).

Selected Reference

*Frackman, Noel. *John Storrs* (exh. cat.). New York: Whitney Museum of American Art, 1986.

46

THE TRANSCENDENTAL PAINTING GROUP:
ITS EVOLUTION AND LEGACY

The Transcendental Painting Group (TPG) was founded by a small group of painters in New Mexico during the summer of 1938 for the purpose of promoting nonobjective art. A short-lived, loosely run group, it had ten members, who ranged in age from their early twenties to their mid fifties. The artists were based mostly in the towns and villages of Albuquerque, Santa Fe, and Taos, towns separated from one another by seventy or more miles of dusty road. Only Agnes Pelton lived hundreds of miles away in the isolated desert of Cathedral City in southern California. Nevertheless, the influence of the TPG extended well beyond its remote location and brief life span of barely three years.

The collegiality of the group undoubtedly helped buoy the aspirations of several of its members, who, engaged in independent searches for creative expression within the realm of nonobjective art, strove to achieve credibility and recognition for their work at a time and in a place where the status quo of realism was holding fast. For the younger artists – Ed Garman, Robert Gribbroek, Florence Miller, and Horace Towner Pierce – the TPG years coincided with their early efforts to work in nonrepresentational styles; for the older members – Emil Bisttram, Lawren Harris, Raymond Jonson, William Lumpkins, Agnes Pelton, and Stuart Walker – the group offered some support and affirmation of their exploration of progressive ideas, which was already well underway. The formation of the TPG – though heralded at the time by only a relative few beyond the borders of New Mexico – marked the struggle of artists outside the well-known and influential artistic centers of New York and Paris to explore some of the most advanced and progressive aesthetic issues of the day.

The circumstances that catalyzed the formation of the TPG were hardly unique to this organization. Simply put, a group of artists who shared in broad terms a common commitment to abstraction and nonobjective expression came together with the notion that their impact would be greater as a group. The same could certainly be said of the American Abstract Artists (AAA) or, for that matter, of many other artistic associations, whether they were progressive or traditional in their credo. But though the history of the AAA has been well documented by scholars in recent years, relatively little has been published to date on the formation, purpose, reception, and legacy of the TPG.

The artistic community of the Santa Fe–Taos region was in many ways parallel in context to the environment that progressive artists such as those in the AAA experienced in New York City and other urban centers. Santa Fe and Taos had been flourishing colonies for artists and writers since World War I. By the 1930s, when several future TPG members were settled in northern

New Mexico, the region was thoroughly imbued with an appreciation for realism that glorified the breathtaking landscape and picturesque indigenous life-style. Artists such as Ernest Blumenschein, Bert G. Phillips, and Joseph Henry Sharp, who had been among the first to rediscover the region in the 1890s, were but a few among the many academically trained painters there who had achieved considerable public acclaim.[1] They and many of their colleagues who formed the first generation of Taos artists participated in the Taos Society of Artists (1915–1927), a conservative organization whose primary purpose was to circulate and promote nationally exhibitions of its members' work. These realist painters of the Southwest were essentially partisan to the same ideals as their better-known urban contemporaries, the so-called Ashcan school of painters and, later, the regionalists and Social Realists.

Though seemingly isolated from the mainstream, Taos and Santa Fe were not immune to the infiltration of a modicum of modernism, as reflected in the work of a younger generation. Painters such as Jozek Bakos and Willard Nash, both members of the group Los Cinco Pintores, as well as Andrew Dasburg, Victor Higgins, and Gina Knee, revealed in their work various degrees of generalized form or abstraction deriving from Cézanne. Moreover, American modernists of the national stature of Marsden Hartley and Georgia O'Keeffe visited Taos in the 1910s, as did John Marin in the late 1920s, and they exerted some influence upon artists in the region. But even these three artists, who had been active participants in the first wave of American abstraction in New York during the 1910s, had by the time of their visits to New Mexico reverted to essentially representational styles. Thus, when the first future TPG members arrived in New Mexico in the mid 1920s and early 1930s, they encountered a strong tradition of representational art mellowed slightly by modernist tendencies.

All the TPG members except William Lumpkins came to New Mexico from other parts of the country. Raymond Jonson, a cofounder of the group, was the first to arrive, settling in Santa Fe in 1924, two years after his initial visit to the area. His work at this time reflected definite modernist tendencies within a generally abstract style. He had not yet attained a nonobjective vision, and this was true for most of the group until the early and mid 1930s. Stuart Walker was probably the first to evolve a nonobjective style (about 1930–1932), and he was followed closely by Raymond Jonson and William Lumpkins. Emil Bisttram and Lawren Harris followed suit about 1935. The younger members, Ed Garman, Robert Gribbroek, Florence Miller, and Horace Towner Pierce, were only beginning to paint seriously about 1935 or 1936, but by 1938 they each had produced nonobjective works. Only Agnes Pelton never developed a truly nonobjective

1
Three important books that discuss the formation of these art colonies are: Van Deren Coke, *Taos and Santa Fe: The Artist's Environment* (Albuquerque: University of New Mexico Press, 1963); Sharyn R. Udall, *Modernist Painting in New Mexico, 1913–1935* (Albuquerque: University of New Mexico Press, 1984); and Charles C. Eldridge *et al, Art in New Mexico, 1900–1945: Paths to Taos and Santa Fe* (Washington, D. C., and New York: National Museum of American Art and Abbeville Press, 1986).

style. Thus, the work of future group members in the ten or twelve years leading up to the TPG founding was among the most advanced in the area; however, it was greeted with some public skepticism.

Although the vision and approach of each future TPG member was distinct and individual, during the late 1920s and the 1930s these artists gradually began to develop the coterie of sympathetic colleagues from which the group would eventually evolve. Walker and Lumpkins met in Albuquerque in 1930. Also in that city, the University of New Mexico served as a place where young painters interested in progressive ideas could encounter one another. By 1929 Lumpkins, for example, had found kindred spirits there in fellow artists Gribbroek and Knee as well as James Morris and Cady Wells.[2] Jonson operated an art supply store in Santa Fe where he met numerous artists, including Lumpkins (about 1935). Lumpkins also recalled encounters in Santa Fe with modernists Willard Nash and B. J. O. Nordfelt, the latter an early mentor of Jonson's who may have first introduced him to the region.[3] Bisttram, the other TPG cofounder, settled in Taos in 1931. The following year he opened a school of art that, in the mid 1930s, attracted students such as Gribbroek, Miller, and Pierce, all of whom he later enlisted as group members. Bisttram's pupil Miller recalled that the teacher had had little tolerance for Blumenschein, Phillips, Sharp, and other established realists working in Taos, and that he had not encouraged his students to mingle with them. Ironically, though, Bisttram himself painted in both realist and nonobjective manners throughout his career. Nevertheless, he urged on his students a rigorous course of study of nonobjective art.[4]

During the mid 1930s several of these forward-thinking artists began to exhibit together locally. For example, in 1933 Raymond Jonson organized a show at the Museum of Fine Arts in Santa Fe which included his own drawings as well as oils by future TPG member Pelton and watercolors by modernist painter-printmaker Wells. This exhibition not only marked an attempt to promote a more advanced vision of art in the region, but it also documented Jonson's admiration for Pelton's work.[5]

A more significant show with a direct link to the formation of the TPG opened on June 1, 1938, at the same venue. The exhibition, *Southwest Contemporary Art Group,* included the work of seven future TPG members – Bisttram, Gribbroek, Jonson, Lumpkins, Miller, Pierce, and Walker – as well as that of Knee and Wells. The few extant reviews indicate a mixed public reception. In a brief notice one unnamed reviewer from the *Santa Fe New Mexican* described it as "a startling and very beautiful exhibition . . . [of] nine painters who are making a vital and

2
Lumpkins says he met Gribbroek at the University of New Mexico in 1930 and later introduced him to Bisttram; taped interview of William Lumpkins by Susan E. Strickler, Nov. 15, 1990.

3
Ibid.

4
Taped interview of Florence Miller Pierce by Susan E. Strickler, Nov. 13, 1990.

5
It remains unclear when Jonson first became aware of Pelton's work. She did exhibit in the Armory Show of 1913, which Jonson saw when it traveled to Chicago. It is also difficult to discern from Jonson's correspondence with Pelton during the 1930s and 1940s whether they ever met; their letters indicate, however, that as late as 1933 they had not.

sincere effort to present stimulating work. . . . The result will be hated by some, adored by others, but will interest all."[6] A more incisive and partisan discussion by Alfred Morang appeared in the paper two days later. Morang, a writer, violinist, and art critic as well as a painter working in an expressionist, figurative manner, had moved to Santa Fe with his wife in 1937. They were befriended by Jonson and soon became part of the local art scene. In a defensive tone that suggests a controversial reception to the show, Morang expounded upon the difference between abstract and nonobjective art for the benefit of "hide-bound academicians and tradition-tied dealers," and he described the emergence of these approaches from earlier modern movements led by the Impressionists, Cézanne, and the Cubists.[7] His summary of the exhibited work noted that Bisttram, Knee, and Wells were represented by abstract compositions, and Gribbroek, Jonson, Lumpkins, Miller, Pierce, and Walker by nonobjective work. Whatever the public attitude was to the show, the artists themselves must have perceived enough enthusiasm to have met on June 10, 1938, in order to discuss the founding of a formal group with the specific mandate of promoting nonobjective art.

At least two or three meetings were held during that summer at the studios of cofounders Bisttram and Jonson. Both dynamic men invited colleagues to enter the discussion; Jonson asked Knee, Lumpkins, Walker, Wells, and Harris, a Canadian artist who had recently arrived in Santa Fe; and Bisttram brought his students Gribbroek, Miller, and Pierce.[8] Alfred Morang and Dane Rudhyar, who was an astrologer, composer, painter, and author, were invited to join these meetings as discussants but not as fellow painters.[9] Knee and Wells declined membership because they felt their work, though abstract, was tied closely to landscape imagery, and they therefore rejected the notion that their painting was nonobjective. No minutes or notes from the meetings exist, but in a letter to his brother Arthur on July 26, 1938, Jonson summarized the work of the group thus far:

> During June a group of us arranged an exhibition with the idea of seeing how our works looked together. From it we planned to form a group for the purpose of exhibiting — talking together and attempting to publish a few folders or booklets etc. Out of it we have formed a group. . . . The work of all are examples of the non-objective. Some of them do other types of works but we are considering only the non-objective. I'm wondering what you will think of our designation Transcendental Painting Group. We have spent a lot of time on the name and we have all agreed on this.[10]

On his list of members, Jonson noted that he was chairman and Lumpkins, secretary-treasurer. Although Pelton did not come from California to participate in these formative discussions, Jonson listed her as a member.

6
"Non-objective and Abstract Paintings in Startling Show," *Santa Fe New Mexican,* June 2, 1938. All cited reviews of this show were gleaned from the files of the Jonson Gallery at the University of New Mexico. I am grateful to Tiska Blankenship and Joe Traugott for opening these files to me. MaLin Wilson, a former curator at the Jonson Gallery, compiled the unpublished TPG bibliography that first brought those reviews to my attention.

7
Alfred Morang, "Abstract and Non-objective Painters, in Show at Museum, Are the Adventurers of Art,'" *Santa Fe New Mexican,* June 4, 1938. For a discussion of his painting and artistic activities see Walt Wiggins, *Alfred Morang, A Neglected Master* (Roswell, New Mexico: Pintores Press, 1979). Betty Bauer and Marion Love wrote a brief biographical summary, "Profile of a Legend: Alfred Morang," *Santa Fean* (Apr. 1978), pp. 10–11.

8
Harris seems to have missed some of these early formative meetings, as he was traveling in Colorado and Maine much of that summer. However, he was in correspondence with Jonson during the time of the formation of the group.

9
For a detailed account on Rudhyar see Robert C. Hays, "Dane Rudhyar and the Transcendental Painting Group of New Mexico 1938–1941" (M.A. thesis, East Lansing: Michigan State University, 1981).

10
Letter from Raymond Jonson to Arthur Jonson, July 26, 1938; Jonson Papers, Archives of American Art, roll R41:530.

Apparently Dane Rudhyar was the first to propose the designation "transcendental" to describe the group. In one sense, the choice was practical because the term was being publicized nationally in conjunction with the centenary of the famous New England writers in the circle of Emerson and Thoreau.[11] The painters, however, claimed no philosophical link to the writers. Rather, the published manifesto of the group, which was probably authored in large part by Jonson and Rudhyar, explained the more significant reason for the choice:

> The word Transcendental has been chosen as a name for the group because it best expresses its aim, which is to carry painting beyond the appearance of the physical world, through new concepts of space, color, light and design, to imaginative realms that are idealistic and spiritual. The work does not concern itself with political, economic or other social problems.[12]

The manifesto also boldly stated that the term was "being used first in order to differentiate between it and abstract or non-objective for we feel neither of the two latter terms expresses exactly the free creative attitude inherent in the work in which we are primarily interested."[13] This implied that transcendental painting was even more advanced than nonobjective.

According to the bylaws of the TPG, membership was open to painters living in America "whose most characteristic works can be designated 'transcendental painting.'"[14] Artists such as Bisttram would not be excluded if they also worked in abstract or even representational styles; however, only their nonobjective work would be considered transcendental. The manifesto did not prescribe for the members any set style or approach within the transcendental mode. Some approached their art through an intuitive response, others through an appreciation of the metaphysical and occult, and still others through an intellectual and analytical vision.

The primary goals of the organization were to collect the best examples of transcendental painting, to build a gallery in Santa Fe to house that collection, to encourage new artists to adopt this creative approach to painting, and to promote transcendental painting through publications and traveling exhibitions.[15] Much of this work was to be supported by the establishment of the American Foundation for Transcendental Painting, a separate governing body of which Pelton was elected honorary president; Harris, president; Bisttram and Rudhyar vice presidents; Jonson, secretary; Lumpkins, treasurer; and Morang, publicist.

The publication of a manifesto and the development of bylaws for both the TPG and the foundation suggest a structure and a formality that, in fact, never evolved within the organizations. Rather, the group remained informal and met infrequently. Several members never met one another, and Pelton, in spite of her honorary presidency, may never even have visited

11
Hays, "Dane Rudhyar and the Transcendental Painting Group," p. 13.
12
Transcendental Painting Group (published manifesto, Santa Fe: American Foundation for Transcendental Painting, 1938), n.p.
13
Ibid.
14
By-laws of the Transcendental Painting Group, sec. 1; copy in files of Jonson Gallery.
15
By-laws of the American Foundation for Transcendental Painting, article II; copy in files of Jonson Gallery.

Santa Fe or Taos during the TPG years. Rudhyar and, to a lesser extent, Morang became vocal spokesmen for the group, but sometimes their articles expressed their own personal beliefs rather than a consensus of the artists'.

The first published announcement of the formation of the group appeared on August 21, 1938, in the *New Mexico Daily Examiner* in the form of lengthy articles by Morang and Rudhyar. Rudhyar addressed parallels he found in contemporary music and dance, and Morang expanded upon his usual art-historical explanation of the emergence of abstraction and non-objective painting from earlier modern movements. His discussion concluded that Kandinsky had been the first artist to break cubist ties to the object and to create "paintings that did not depend upon the external world, paintings that reached the state of pure painting," and that he was an important artistic mentor for the TPG.[16]

Kandinsky, who, as Morang described it, had made this "leap into the unexplained," was certainly a major influence on several TPG members, in terms of both his theoretical writings and his painting. Miller recalled that Kandinsky's treatise *Concerning the Spiritual in Art,* which had first been published in 1912, and his text of 1926, *Point in Line and Plane,* were important sources for Bisttram and his students.[17] In particular, Bisttram, Garman, Gribbroek, Miller, and Pierce studied and admired Kandinsky's geometric style of the 1920s. Certainly, the other TPG members were well aware of Kandinsky's work; Harris's brief nonobjective period, which lasted from about 1936 to 1942, reflected a Bauhaus aesthetic.

Kandinsky's interest in mysticism and theosophy appealed especially to both TPG cofounders. As a young artist in New York, Bisttram had become thoroughly acquainted with these ideas at the Master Institute of the Roerich Museum, where he taught during the early 1920s. Consequently, he frequently brought discussions of theosophy into his Taos classroom, and he made the writings of Madame Blavatsky and other proponents of the discipline required reading for his students.[18] The Russian mystic and painter Nicholas Roerich was an important conveyor of theosophy and occult ideas for Bisttram through the Master Institute and for Jonson through the Cor Ardens in Chicago. Roerich had fled Russia during the Revolution, going first to Europe and arriving in New York in 1921. Out of his ambitious mission to achieve an international society devoted to the ideals of brotherhood achieved through art, he established various societies and organizations throughout the world.

Roerich had in common with theosophy a belief in the synthesis of positive, creative forces for the attainment of universal peace, whether through the melding of eastern and western

16
Alfred Morang, "The Transcendental Painting Group, Its Origins, Foundation, Ideals and Works," *New Mexico Daily Examiner,* Aug. 21, 1938, p. 3. Another article by Morang, "Introducing the Transcendental Painting Group Which Dismisses Traditions in Art," appeared in *Santa Fe New Mexican* on Aug. 20, 1938.
17
Interview of Florence Miller Pierce by Susan E. Strickler, Nov. 13, 1990.
18
Ibid.

religions or through the synthesis of the various arts and sciences. These notions had been cast broadly throughout the international art world during the early twentieth century, and major figures such as Kandinsky, Franz Marc, Kasimir Malevich, and Piet Mondrian were among those attracted to mysticism and the occult. However, though Rudhyar and several TPG members were interested in these philosophies, it is important to reiterate that no official philosophical platform had brought the TPG together, and no philosophical consensus existed among the members. Walker once described his work as purely decorative. More recently, Garman recalled "Rudhyar's enormous tendency to impose philosophical significance on material that most of us, then, thought of as pure plastic means. The main idea was for each artist to develop works of art free of any kind of derived influence or imposed meaning. The imposed meaning was especially anathema to some of us."[19] Garman stated that he and others, such as Lumpkins, saw the primary motive behind the TPG as simply the desire to promote nonobjective art through exhibitions and publications.

In this endeavor the TPG displayed a moderate measure of success. Many of the members exhibited independently, but only two or three group shows were mounted in New Mexico, at the Museum of Fine Arts in Santa Fe and at the university in Albuquerque. On a national level, several members' works were exhibited together at large expositions; however, the entire membership never exhibited together outside New Mexico. Seven members exhibited in January 1939 at the Golden Gate International Exposition in San Francisco and four in March 1939 at the New York World's Fair.[20] The following year, the TPG was invited to exhibit at the World Exposition in Paris; however, all of the works sent there, except Lumpkins's entry, were lost as a result of the German invasion.

An invitation to exhibit also came from the formidable Hilla Rebay, director of the Solomon R. Guggenheim Foundation, which operated the Museum of Non-objective Painting in New York. This recognition from Rebay undoubtedly stirred up some pride among members of the TPG because not only was this museum devoted to the promotion of nonobjective art, but it also housed the most extensive collection of works by their mentor Kandinsky and his circle. Rebay's interest in the spirituality of art undoubtedly attracted her to the work of several TPG members, and she may have been acquainted with Bisttram and Jonson, whose ties to New York were the strongest of the group.[21] Rebay included works by Bisttram, Gribbroek, Harris, Jonson, and Pelton in her show *Twelve American Non-Objective Painters* during May and June 1940. A newspaper article by Morang announced Rebay's invitation to TPG members to

19
Ed Garman, "Notes on TPG – For Susan E. Strickler" (typescript), Dec. 1990.

20
For a listing of the works see Department of Fine Arts, *Contemporary Art,* San Francisco: Golden Gate International Exposition, 1939. Alfred Morang discussed the entries of five of the exhibitors (excluding Lumpkins and Pierce) in his article "Transcendental Painting Group Sends Exhibition to San Francisco to Be Shown During World's Fair," *Santa Fe New Mexican,* Jan. 17, 1939. Bisttram, Jonson, Lumpkins, and Walker were the only TPG members included in the exhibition *American Art Today* at the New York World's Fair; Bisttram's entry was a southwestern realist subject.

21
Apparently, the Guggenheim Foundation had contacted the TPG as early as November 1938, but Jonson had decided it was too soon in the history of the group to enter into negotiations; letter from Raymond Jonson to Arthur Jonson, Nov. 2, 1938; Jonson Papers, Archives of American Art, roll R41:538.

submit their work to the museum, and noted the success and achievement that meant for the group.[22] Though seven of the original TPG members – excluding Lumpkins and Pierce – had submitted works for Rebay's consideration, their enthusiasm may have been somewhat dampened because the entries by Miller and Walker were not selected. Rebay organized for late summer of that year another group show, which included work by Harris, Jonson, and Walker.[23]

By the spring of 1940, however, the TPG had already begun to wane, and its members began to disperse. The first to leave were Bisttram's students Miller and Pierce. Having lived and studied in Taos for nearly three years, the couple, who had married in 1938, was restless to move on, as Miller later recalled.[24] Pierce had ambitions to produce an abstract movie, and, consequently, they left Taos to seek funding for the project in New York. In January 1940 Walker died, having suffered from a debilitating heart condition for several years. Soon thereafter, Garman, a former student at the University of New Mexico and a friend of Jonson's, was invited to join the TPG, becoming the tenth and last member. As the war activities widened, others were called away: in 1941 Lumpkins was commissioned into the Navy in California, and Harris was called home to Canada; in 1943 Garman also left to serve in the Navy. By 1941 even Bisttram had begun to divide his time between teaching in New Mexico and in other locations, opening a school in Phoenix and, two years later, another in Los Angeles. The distress over the decline of the group was keenly felt by Jonson, who had worked the hardest to form it and to keep it together. In early 1941 he wrote Rudhyar:

> On Tuesday we plan to drive up to Taos. Have not been there for a long time and I want to see what Emil is doing and talk to him about what we should do as far as both the A. F. T. P. and T. P. G. are concerned. How very difficult it is to keep going on such matters. Perhaps if we have some money there would be more of an incentive. . . . Realizing what a fiasco the Guggenheim showing was I wonder if it's really worth while [sic] to do any boosting. After all the main thing is to work. That is difficult enough.[25]

The TPG as an entity dissolved in the early 1940s, although several of the artists continued to work in the spirit of its brief heyday. Miller remarked that she actually did most of her transcendental painting during the time she and Pierce spent in Los Angeles, from about 1942 to 1946.[26] Several others, in particular Bisttram, Garman, Jonson, and Lumpkins, actively continued to explore nonobjective styles. Pelton, who had always been distant from the group, seemed to have been the least affected.

Looking at the TPG within the context of the American art scene of fifty years ago provides a measure of its legacy. These progressive artists wrestled with many of the same issues as did

22
Alfred Morang, "Transcendental Painting Group Invited to Send Examples to Guggenheim" (newsclip from unnamed paper), Apr. 11, 1940; files of Jonson Gallery. I am also grateful to Martin Diamond for sharing with me his correspondence regarding the TPG show at the Museum of Non-objective Painting.

23
Harris, Jonson, and Walker were included in *Six American Non-objective Painters* at the Museum of Non-objective Painting (Aug. 6–Sept. 30, 1940); see Angelica Zander Rudenstine, *The Guggenheim Museum Collection: Painting 1880–1945*, vol. 2, (New York: Solomon R. Guggenheim Museum, 1976), p. 700.

24
Taped interview of Florence Miller Pierce by Susan E. Strickler, Nov. 13, 1990.

25
Letter from Jonson to Dane and Malya Rudhyar, Jan. 15, 1941; copy in files of Jonson Gallery.

26
Taped interview of Florence Miller Pierce by Susan E. Strickler, Nov. 13, 1990.

their more visible and activist counterparts in the AAA in New York. The TPG, like the AAA, struggled for recognition and credibility from a public that favored the dominant realist vision of regionalist painters of the American scene. Both these vanguard groups tried to convey to a skeptical audience the social relevance of abstract and nonobjective art. As Garman, Lumpkins, Miller, and others have noted, the TPG was well aware of the struggles of the AAA against the dominance of regionalist and social realist painting and against many American museums, especially the Museum of Modern Art, which favored European abstract artists over their American counterparts. Although there was minimal contact among members of the AAA and the TPG, there was a parallel in their striving. The years of greatest activity for the AAA – 1937 to 1942 – coincided with the brief life span of the TPG. Both groups formed similar strategies to promote their work through exhibitions and publications.

Undoubtedly, the most striking difference between these two groups was their respective settings. The AAA sprang up in a cosmopolitan city that was soon to become the dominant artistic center of the world, but the TPG was sheltered in fairly remote art colonies. AAA members had much more intense and direct interaction with European art and artists: most had traveled abroad, and several had participated in European artists' groups or salons. Conversely, the war brought major figures such as Léger and Mondrian to New York. In contrast, few TPG members had traveled abroad prior to the formation of the group, and their primary knowledge of European modern art came through visits to urban art centers such as Chicago or New York and from various art publications.[27] However, most TPG members preferred the New Mexican environment. For some, the quality of light and atmosphere and the abstraction inherent in the pattern and design of Native American art exerted identifiable influences on their vision. The relative isolation and the sense of natural and cultural history of the region were also significant factors in providing a focus and a sense of tradition to the artistic lives and work of other members. Although several group members left New Mexico within three years of the founding of the group, all but Garman and Harris eventually resettled in the region.

Both the AAA and the TPG embraced a multiplicity of abstract and nonobjective styles; it should be stressed that no one form of expression or approach characterized either group. Even so, a difference in focus can be discerned between the two groups, and is reflected, in part, in the names they chose for their respective organizations. Aesthetically and philosophically, the majority of AAA members seemed more closely aligned with progressive movements — especially Cubism, its derivatives, and biomorphic Surrealism, all movements tied

27
Harris and Pelton had studied in Europe. Bisttram was born in Hungary, but had immigrated at the age of eleven with his family to the United States. Walker had served abroad during World War I, but this author has no knowledge that he studied art there. Garman, Jonson, Lumpkins, Miller, and Pierce had not traveled abroad prior to World War II.

ultimately to figuration – that coalesced in Paris under the influential umbrella of the artists' group Abstraction-Création. In contrast, the TPG showed greater affinity for Kandinsky's geometric style and his interest in mysticism, and the manifesto of the group made reference to the potential for art to express man's spiritual nature. Though the New York group chose the nomenclature *abstract,* its New Mexican counterpart preferred *transcendental* or *nonobjective* to underscore the notion that painting was not abstracted from nature but, rather, transcended "the appearance of the physical world . . . to imaginative realms that are idealistic and spiritual."[28] The majority of the AAA members rejected this notion of spirituality in their art.

Despite these differences, both groups helped bring a new level of expression – abstract and nonobjective – into American art. They were the second generation – the second wave, so to speak – to draw upon the resources of Europe and to forge new work within the developing international power of the United States. Both groups reflect the growth of this country as a dominant force in the art of this century. They formed important links that helped America bridge the cultural gap between its status as an artistic colony of Europe up until World War II and its emergence as the international artistic capital afterward. Many members of the AAA and the TPG continued to explore new realms of nonrepresentational art; some contributed to the new trends, and others incorporated new styles into their basic leitmotifs. Only in recent years have historians reassessed the role of these groups in the development of Abstract Expressionism and other truly American contributions to late twentieth-century art. The contributions are not considered equal. The AAA, a larger group operating at the core of the American artistic scene, exerted a broader and more visible influence. But, despite its small membership, its relative isolation, and its brief life span, the TPG claims an important legacy.

28
Alfred Morang, *Transcendental Painting* (Santa Fe: American Foundation for Transcendental Painting, 1940), n.p.

EMIL BISTTRAM (1895 – 1976)

47

Upward Flight No. 2, 1940

oil on canvas

47⅞ × 36 in.

(121.6 × 91.5 cm)

signed at lower right:

BISTTRAM

A personality replete with apparent contradictions, Emil Bisttram was a cofounder of the TPG, a dedicated teacher, and an important promoter of Taos, New Mexico, as a regional art center. Highly intellectual and among the most spiritual members of the TPG in his approach to art, Bisttram had quit school in the eighth grade. In the late 1910s he established a successful advertising agency in New York, only to turn to painting full time in about 1925. At night school he met Jay Hambidge, who formalized the theory of dynamic symmetry, a complex concept of the ideal composition, which reportedly had been used by the Greeks and was based upon the proportional relationship of the golden section and the logarithmic spiral. Bisttram became a strong proponent of this theory both as an artist and as a teacher. His penchant for spiritualism was solidified during the five years (1925–1930) he taught at the Master Institute of the Roerich Museum in New York. This school, founded by the Russian mystical philosopher and painter Nicholas Roerich, offered a curriculum drawn from ideas of theosophy, occult philosophies, and the unity of all the arts. In 1932 Bisttram settled in Taos, where he established his first school and lived for most of his life.[1]

Bisttram referred to himself as a "classic modernist," alluding to the progression of his painting from realism to abstraction and, ultimately in the mid 1930s, to a nonobjective art embodying his search for a new expression for a new world order. Although Bisttram strongly urged his students to pursue a cosmic approach and a nonobjective aesthetic, he himself continued to paint both traditional, realist canvases of indigenous southwestern subjects and nonobjective compositions.[2]

Upward Flight No. 2 characterizes his effort to convey in nonobjective terms the sensation of a universal phenomenon. Through the precision of execution and composition, the viewer intuitively senses not only Bisttram's emphasis on good craftsmanship but, more importantly, the mathematical and proportional structure he imposed on the design. Based upon the primary shapes of circles and rectangles, his geometric vocabulary reflects the hard-edged Bauhaus aesthetic and the principles of Kandinsky, whose paintings and writings exerted a strong influence on the American.[3]

The formation of the TPG helped support and formalize Bisttram's progressive ideas, as it did for his fellow cofounder, Raymond Jonson. Although the students Bisttram had enlisted as members of the group – Florence Miller, Horace Towner Pierce, and Robert Gribbroek – as well as several colleagues had left the region by the early 1940s, Bisttram maintained a strong foothold in Taos. For the rest of his life he continued to explore the universal and spiritual potential of nonobjective painting.

Notes

1 Roerich, who had visited Taos in 1921, may have suggested to Bisttram that he visit the village (Wiggins, p. 18). Bisttram established other art schools in Phoenix and Los Angeles in the 1940s.

2 Bisttram also worked as a muralist in the mid 1930s; on a Guggenheim Fellowship he studied with Diego Rivera in Mexico in 1931.

3 Kandinsky's treatise *Concerning the Spiritual in Art* was an important text for Bisttram and his students.

Selected References

Hurst, Tricia. "Emil J. Bisttram," in *Southwest Art,* vol. 7, no. 10 (Mar. 1978), pp. 83–87.

*Wiggins, Walt. *The Transcendental Art of Emil Bisttram.* Ruidoso Downs, New Mexico: Pintores Press, 1988.

Witt, David. *Emil James Bisttram.* Taos, New Mexico: Harwood Foundation, 1983.

47

ED GARMAN (born 1914)

48

No. 240, 1941

oil on masonite

47⅞ × 48 in.

(121.6 × 121.8 cm)

signed at lower left:

Garman

(see p. 118)

49

No. 261, 1942

oil on masonite

35¹⁵/₁₆ × 36¹/₁₆ in.

(91.3 × 91.6 cm)

inscribed on reverse: *TOP/
MAY 3–6 1942/BY
ED GARMAN/No. 261*

(see p. 119)

In 1941, almost three years after the formation of the TPG and not long before it dissolved, Ed Garman became the last painter to join the group. Born in Bridgeport, Connecticut, and raised in the Lehigh Valley of Pennsylvania, Garman arrived in Albuquerque in 1933 to attend the University of New Mexico. During the next few years, several factors nudged him toward the risky career of painting, and these were to affect his movement toward abstraction. The light and atmosphere of New Mexico immediately struck Garman, who explained that its "quality of airless brilliance was to become an ingredient of paintings that were to arrive in the future."[1] As a student working in the university theater, he was impressed by the stark, dramatic sense of structure and unusual illumination of avant-garde stage sets by two turn-of-the-century European designers, Adolph Appia and Edward Gordon Craig. Garman also became intrigued by the beauty and inherent abstraction of Native American pattern and design, which he encountered in 1934 while working on a WPA archaeological dig sorting pottery shards from pueblo ruins. In 1935, not long after seeing an exhibition of paintings by van Gogh in Chicago, Garman finally began to paint his first abstractions.

In his exploration of the nonobjective idiom, the artist has been intellectually concerned with the basic formal issues relating to color, shape, and structure. His work reveals an underlying progression toward simplification of compositional elements and color, a trend that can be discerned by comparing the two pictures shown here (see overleaf), which date only about a year apart.

Garman painted *No. 240* in 1941, following a trip to New York the preceding fall.[2] At the Museum of Non-objective Painting, he had studied the language and systems of color and geometric shapes used by Kandinsky and Rudolf Bauer during the Bauhaus years. On Garman's way back to New Mexico, as he mulled over the new "tools" he had acquired in New York, he visited the Field Museum of Natural History in Chicago. There, he encountered tanks of "colorful and exotic fish floating freely in their gravity-free environment."[3] In retrospect, Garman recalled that, suddenly, "the gravity-free feeling of the Kandinskys and Bauers made sense.... I knew why that kind of painting gave such a cosmic feeling, bigger than life, spiritual, if you will."[4] *No. 240* belongs to a group of works in which Garman explored the Bauhaus artists' hard-edged geometries of circles, rectangles, and triangles. He created a sense of weightless atmosphere largely by the juxtaposition of shapes: some forms, such as circles, assert the flatness of the picture plane, and others, such as triangles and trapezoids, suggest their own recession into space. Unlike his European mentors, Garman did not model any of the shapes, but worked in flat, unmodulated areas of color, enhancing the dynamic arrangement of stark silhouettes against the yellow field.

Painted one year later, *No. 261* distinctly indicates the artist's progression toward the simplification of form and color. Recently, he restated the objectives he had sought to achieve in this work: "Because I was color oriented, looking for ways to make color construct my idea of painting, I found that getting rid of a profusion of shapes which had complex organizational demands, I let color develop into larger and larger areas of simplicity.... I felt that the painting should do the most with the least...."[5] *No. 261,* in its square format, predominant rectangular vocabulary, and palette of a few saturated colors, recalls compositions from the 1910s and 1920s by Russian Suprematist Kasimir Malevich.

Garman purposely worked within a square format in order to preclude any allusion to the traditional horizontal composition of landscapes or the vertical orientation associated with figurative works. He achieved a dynamic tension by dividing the composition with contrasting colors – blue and yellow – and by suggesting spatial recession, through overlapping forms within the yellow rectangle and through color within the blue rectangle. His focus on the reduction of a painting to its essentials – color, form, surface – through a purely nonobjective idiom not only harks back to the Suprematists but also presages issues that Americans would address in the 1960s and 1970s.

Because the TPG had largely dissolved by 1941, Garman's associations with other members were somewhat limited.[6] Raymond Jonson, whom Garman had met in 1938, brought him into the group. The two remained close friends, and Garman, though he never studied with Jonson, was encouraged by him to pursue his work. In 1943 Garman left New Mexico in order to serve in the United States Navy in California, where he then settled and has continued actively to explore nonobjective modes.

Notes

1 Letter from Ed Garman to Virginia Mecklenburg, Feb. 15, 1988; curatorial files, National Museum of American Art, Washington, D.C.

2 *No. 240* was exhibited in a one-man show in March 1942 at the University of New Mexico Art Gallery and in a group show in the fall of that year at the Museum of Non-objective Painting in New York.

3 Letter from Ed Garman to Susan E. Strickler, Jan. 11, 1991.

4 Ibid.

5 Ibid.

6 Garman also knew Lawren Harris, William Lumpkins, Agnes Pelton, and Stuart Walker; however, he never met Bisttram, Gribbroek, Miller, or Pierce during the years of the TPG.

Selected Reference

Mecklenburg. *Frost Collection,* pp. 72– 74.

48

49

LAWREN HARRIS (1885 – 1970)

50

Untitled, about 1938

oil on canvas

20 × 24 in.

(50.8 × 61 cm)

stamped on reverse:

LAWREN/HARRIS/LSH/

HOLDINGS LTD/21

When Lawren Harris was invited by Raymond Jonson to join the TPG in August 1938, he was already a mature painter. Harris had enjoyed a successful career in his native Canada and had been for over a decade a strong advocate of the spiritual potential of abstract art. Born into a wealthy Ontario family, he briefly attended the University of Toronto before traveling to Berlin in 1904 to study art. During the next four years he became thoroughly familiar with the modernism of the Berlin Secessionists. He also was deeply moved by the work of the nineteenth-century German Romantics, especially the evocative landscapes of Caspar David Friedrich. From this time, landscape – particularly the vast, unpeopled north – became the dominant subject of Harris's oeuvre. Upon his return to Toronto, he tried to promote a national school of landscape, an effort that ultimately led to the founding of the Group of Seven in 1919.[1]

Following the death of his brother in World War I, Harris found solace from the brutality of the era in the spiritual idealism of theosophy; in 1918 he became a member of the International Theosophical Society, and in 1923, a member of its active Toronto chapter. During the next decade he wrote and lectured about the uplifting qualities of the northern landscape and the role painting could play in conveying to the public the spiritual harmony of the wilderness.[2]

Beginning in the 1910s Harris's own painting revealed a consistent trend toward abstraction of landscape imagery, working from a literal, topographical approach exploring post-impressionist and fauvist styles toward highly simplified natural forms in the 1920s and early 1930s. About 1936 Harris achieved a truly nonobjective geometric style that was devoid of any reference to landscape and was inspired by Kandinsky's Bauhaus period. This work began in the midst of Harris's stay in Hanover, New Hampshire (1933–1938), where he initially held a post as artist-in-residence at Dartmouth College; his nonobjective manner continued during his sojourn in Santa Fe (1938–1940).

The untitled landscape shown here probably dates from the mid 1930s, and Harris may have painted it near the end of his time in New Hampshire.[3] He abstracted the composition from a landscape setting, and it depicts hills or mountains, trees, a roadbed, and clouds in the palette of generalized earth colors he favored. Whatever its exact date, this picture clearly evokes Harris's romantic concept of a universal visionary landscape seemingly imbued with an inner life evoked by organic forms and rhythms.

Though his stay in Santa Fe lasted barely two years, Harris was an active participant in the TPG. He exhibited in the major shows of the group in New Mexico as well as at the New York World's Fair (1939–1940), the Golden Gate International Exposition (1939), and the Museum of Nonobjective Painting (1940). He served as president of the American Foundation for Transcendental Painting, the legal, governing body of the TPG. In 1940, Harris returned to Canada for unspecified reasons relating to the war, and he soon settled in Vancouver, where he remained for the rest of his life. His work progressed in an abstract mode, eventually drawing upon the abstract expressionist idiom to explore spiritual concepts.

Notes

1 Devoted to developing a stronger sense of a modern national school in Canadian art and a freedom of artistic expression, the Group of Seven included Frank Carmichael, Harris, A.Y. Jackson, Franz Johnston, Arthur Lismer, J.E.H. MacDonald, and Frederick Varley. They looked primarily to the Canadian landscape for inspiration.

2 A list of Harris's published articles in the *Canadian Theosophist* appears in Murray and Fulford, p. 224.

3 As Harris did not date many of his paintings and drawings, the exact chronology of some of his work – especially regarding his development of a nonobjective style – is somewhat difficult to pinpoint.

Selected References

Lawren Harris: Paintings 1910–1948 (exh. cat.). Introduction by A.Y. Jackson. Toronto: Art Gallery of Toronto, 1948.

Ian McNairn, ed. *Lawren Harris: Retrospective Exhibition* (exh. cat.). Ottawa: National Gallery of Canada, 1963.

*Murray, Joan; and Robert Fulford. *Lawren S. Harris: The Beginning of Vision*. Toronto and Vancouver: Douglas & McIntyre, 1982.

RAYMOND JONSON (1891 – 1982)

51

Watercolor No. 4, 1940

watercolor on rough

watercolor board

image: 24⁹/₁₆ × 31⁹/₁₆ in.

(62.4 × 80.2 cm)

sheet: 25¹⁵/₁₆ × 34¹/₁₆ in.

(65.9 × 86.5 cm)

signed and dated at

lower right: *Jonson 40*

inscribed in graphite at

lower left: *2/11–40–w.c. 4*

inscribed in ink on reverse:

WATERCOLOR NO. 4–

1940/2/11–40/w.c. 4/

Jonson

52

Oil No. 21, 1946

oil on canvas

31 × 27⅛ in.

(78.7 × 68.9 cm)

signed and dated at

lower right: *Jonson/'46*

inscribed on reverse: *oil*

No. 21–1946/Jonson/

RAYMOND JONSON/

VARNISHED 5/28–47

WITH WEBER'S MATVAR

39/GROUND–FLAT

WHITE/ STIPPLED UNDER

PAINTING/TAYLOR'S–

TITANIUM WHITE–

5/27/44/APPROX: 1 PART

COBALT DRIER TO 10

PARTS TURPS

An influential proponent of modernism in New Mexico and a committed teacher for more than fifty years, Raymond Jonson was cofounder, with Emil Bisttram, of the TPG. For Jonson, like Bisttram, the search for the spiritual potential in nonobjective art became a preoccupation. Yet Jonson was more intuitive in his approach than was Bisttram in his rigorous methodology. Born in Iowa and raised in the Midwest and the West in a strict Baptist family, Jonson settled in 1910 in Chicago, where he enrolled in classes at the Chicago Academy of Fine Arts and the Art Institute of Chicago. He met the modernist painter-printmaker B.J.O. Nordfelt, who encouraged him to seek his own form of expression in art. Jonson also became involved in design for the theater, which awakened him to the possible synthesis of the various arts. When the Armory Show traveled to Chicago in 1913, Jonson was exposed firsthand to a potent dose of European modern art. He felt a particular affinity for Kandinsky's search for a universal language that rejected the material world in favor of expressing inner feelings in a purely nonobjective manner. Jonson was supported in his pursuit of artistic spirituality by his association in Chicago during the early 1920s with the Russian artist-mystic Nicholas Roerich and his brotherhood of artists, Cor Ardens.

In 1924 Jonson moved to Santa Fe, where he remained until he accepted a teaching position at the University of New Mexico in Albuquerque in 1934. Like so many artists searching for a personal abstract style, he saw his work progress through a variety of stylistic phases, beginning with impressionist and symbolist portraits and landscapes in the 1910s and early 1920s. In the late 1920s he developed more highly abstracted landscapes, revealing an interest in expressive rather than local color and in the rhythms underlying the structure of nature. By the mid 1930s landscape elements had disappeared from Jonson's work, as he achieved a truly nonobjective, or "absolute," expression that eliminated all reference to the external world.

Watercolor No. 4 relates in style and motif to several watercolors and oils that Jonson painted probably between 1937 and 1941. These works reflect the artist's often highly idiosyncratic imagery of floating organic or trapezoidal shapes allied with one another by energized, jagged parallel lines. The luminosity and transparency of *Watercolor No. 4* were significantly enhanced by his use of an air-

brush. The resulting spattered effect became an integral part of his style from about 1938. Jonson's adoption of the airbrush – which was used by several Bauhaus painters, including Kandinsky and Moholy-Nagy – came shortly after he saw an exhibition of the New Bauhaus when he visited Chicago in 1937.[1]

Painted well after the dissolution of the TPG, *Oil No. 21* relates in its primary motif of concentric circles within an irregular trapezoid to a series of seventeen works called *Pictographical Compositions* (1946–1947); Jonson himself noted that the series was generally inspired by his contemplation of pictographs and petroglyphs.[2] Occasionally, when Jonson was at work on a series, he would temporarily break to explore tangential ideas, as seems to have been the case with *Oil No. 21*.[3] Its composition of a few forms is emblematic of the artist's emphatic exploration of simplicity of design and expressive harmony of color. Modern in its bold, stark concept, this work provokes comparison with the reductive compositions of the later movements of color field painting, Pop Art, and even Minimalism.

Jonson continued his prolific career, working toward achievement of a nonobjective art that expressed themes of universal order and harmony until 1978, when declining health forced him to stop painting. In 1950, the Jonson Gallery opened at the University of New Mexico; today, it houses the most important collection of paintings by Jonson and many of his fellow TPG members.

Notes

1 Jonson's biographer and fellow TPG member Ed Garman notes that the artist adopted the airbrush independent of any specific Bauhaus influence; see Garman, pp. 120 and 195.
2 Garman, p. 134; for an illustration of one painting from the series, see ibid., p. 133, fig. 48.
3 Letter from Ed Garman to Susan E. Strickler, Feb. 2, 1991.

Selected References

Coke, Van Deren, ed. *Raymond Jonson: A Retrospective Exhibition* (exh. cat.). Introduction by Ed Garman. Albuquerque: University of New Mexico Art Museum, 1964.

*Garman, Ed. *The Art of Raymond Jonson, Painter.* Albuquerque: University Press of New Mexico, 1976.

51

52

WILLIAM LUMPKINS (born 1909)

53

Untitled Abstraction, 1937

watercolor on paper

8 × 13 in.

(20.3 × 33.1 cm)

signed and dated in ink

at lower center:

LUMPKINS 37

inscribed in graphite on

reverse: *9*

As the only native-born son of New Mexico to pursue abstraction during the 1930s, William Lumpkins was the sole member of the TPG to choose watercolor as his primary medium. Though also an architect known internationally for his designs in adobe styles and his use of solar technology, he has consistently continued to paint watercolors in a distinctly separate career, which in the past decade has garnered more public attention. Raised on ranches in southwestern New Mexico and Arizona, he received early schooling informally from tutors. As a high-school student in Roswell, New Mexico, he found encouragement for his artistic interests through friendship with Peter Hurd, a New Mexican artist who had studied with illustrator N. C. Wyeth and who became a noted Southwest regionalist. From this time, landscape became an important source of artistic inspiration for Lumpkins, and it has remained the dominant theme of his oeuvre.

As a student enrolled in art and architecture classes at the University of New Mexico in Albuquerque, Lumpkins was introduced in the early 1930s to the medium of watercolor and to the aesthetic possibilities of modern art. He formed friendships with artists working in modernist styles, including watercolorist and printmaker Cady Wells and painters Gina Knee and James Morris. In 1930 Lumpkins met Stuart Walker, who that year painted the first fully abstract composition Lumpkins had seen, and who would become a fellow TPG member.[1] Within this supportive, collegial environment, Lumpkins also began to move toward abstraction, creating his first abstract watercolor in 1930. Although he studied the watercolors of such masters as Joseph Mallord Turner and John Singer Sargent through published reproductions, Lumpkins in 1931 fortuitously encountered firsthand the work of John Marin, whose watercolors painted in Taos the previous two summers were being readied for an exhibition there. Marin's mastery of the medium, his preoccupation with abstraction of landscape motifs, and his gestural style were strong influences on the younger artist, who was beginning to work in similar directions.[2]

Painted a year before the formation of the TPG, *Untitled Abstraction* characterizes Lumpkins's consistent development in the late 1930s away from recognizable landscape subjects and toward abstract compositions worked in a controlled ges-

tural style and in a rich palette reminiscent of earth colors. Such works capture a feeling about the landscape rather than a depiction of a specific site. Lumpkins has described his approach as painterly, informal, and spontaneous; he begins a watercolor without expectations for a specific result. Though the artist exerts control of the medium, he is intrigued by the fact that the final outcome is tempered by the natural mixing of colors and water against the whiteness of the paper, characteristics inherent in his medium.[3] In part, Lumpkins's interest since adolescence in Zen philosophy has validated his attraction to the role of intuition and accident in the creative process.

Along with his friend Walker, Lumpkins was invited to join the TPG as an original member by Raymond Jonson, whom he had met in 1935 in Santa Fe. Lumpkins was an active participant in the major shows of the group. In 1941 he was commissioned into the Navy and left New Mexico, though he continued to paint and to exhibit. His career as an architect flourished in La Jolla, California, from 1950 to 1967, and in Santa Fe, after his return in 1967. In 1978 he closed his firm in order to be able to paint full time. During the last decade, Lumpkins has painted mostly in the more brilliant colors of acrylics, on a larger scale, and with fewer, more monumental motifs.

Notes

1 Wiggins, p. 13. Lumpkins also designed a studio for Walker; this was built about 1933 (letter from William Lumpkins to Susan E. Strickler, Jan. 31, 1991).

2 Lumpkins was also an admirer of the watercolors of Marin's contemporaries Arthur Dove and Charles Demuth. Taped interview of William Lumpkins by Susan E. Strickler, Nov. 15, 1990.

3 Ibid.

Selected References

*Wiggins, Walt. *William Lumpkins: Pioneer Abstract Expressionist.* Santa Fe: Pintores Press, 1990.

*Wilson, MaLin. *William Lumpkins: Works on Paper, 1930–1986* (exh. cat.). Albuquerque: Jonson Gallery, University of New Mexico, 1987.

53

FLORENCE MILLER (born 1918)

54

Rising Green, 1944

oil on canvas

36 × 32 in.

(91.4 × 81.3 cm)

signed at lower right:

F. MILLER

The youngest of the original members of the TPG, Florence Miller was strongly influenced in her direction toward nonobjective art by her teacher Emil Bisttram.[1] Miller was an impressionable realist painter only eighteen years old when she first arrived in Taos, New Mexico, during the summer of 1936 to study at Bisttram's school of art. Though Miller's interest in art had emerged in childhood, her only previous formal training consisted of a yearlong enrollment at the Studio House of the Phillips Gallery and a six-month stint at the Corcoran School of Art in her native Washington, D.C., during 1935 and 1936. In the winter of 1937, she returned to Taos to study year-round with Bisttram.[2] At his school Miller met fellow student Horace Pierce, whom she married in 1938. That summer Bisttram enlisted both into the TPG, along with their fellow student Robert Gribbroek.

Although Bisttram himself vacillated between realist and nonobjective styles throughout his career, he strongly urged his students to paint pure abstractions that delved beyond the physical world to explore spiritual connotations of universal themes. Miller recalled the rigorous course of study Bisttram offered: his students prepared precise studies of composition and color for each painting, read theosophical and occult literature, and studied the proportional theories of dynamic symmetry.[3] Though the body of Miller's earliest work is small, by 1938 she was painting strong, simple abstractions of a single floral or shell-like motif suspended in a background of indeterminate space, in a palette of two or three contrasting hues. These works signaled her transcendental style, which flourished into the mid 1940s.

Miller and Pierce became the first members to leave the TPG, departing Taos in the fall of 1939 for New York City in order to seek funding for the production of an abstract movie Pierce was designing.[4] Miller's artistic activities were interrupted by the birth of two children, and resumed after the family settled in Los Angeles about 1942. Evoking a vision of primordial or cosmic birth, *Rising Green* is characteristic of the transcendental work Miller painted later in Los Angeles; in these paintings she expanded upon her earlier iconography of organic ovoids, circles, and spirals. These primary shapes have always been integral to her visual vocabulary and probably emerged as a result of her study of

Kandinsky under Bisttram's tutelage. Pierce also explored cosmic themes in *Ellipsis* (1939; cat. no. 56) and other works, but Miller's paintings are more painterly in technique, more intuitive in execution, and more organic in motif.

Following World War II, the Pierces returned to Santa Fe, where they operated a textile design business. Miller halted work as an artist for several years after her husband's death in 1958. Since the late 1960s, she has created wall reliefs in a variety of styles and media, ranging from sandblasted wood and shaped foam to, most recently, luminous geometric panels of resin applied in layers to reflective plexiglas.

Notes

1 The artist has been known professionally as Florence Miller Pierce since at least the 1960s. However, this publication refers to her as Florence Miller, as this was how she signed most of her transcendental paintings and drawings.

2 The artist learned about Bisttram through the Phillips Gallery and through her family's long-standing association with the southwestern region, where her grandparents lived.

3 Taped interview of Florence Miller Pierce by Susan E. Strickler, Nov. 13, 1990.

4 See the catalogue entry (no. 56) on Horace Pierce for details on the abstract movie *The Spiral Symphony.*

Selected References

Brown, Betty Ann; and Arlene Raven. *Exposures: Women and Their Art,* p. 110. Pasadena, California: New Sage Press, 1989.

Gabriel, Kathryn. "Transcendental Art: Paintings Inspired by Landscapes of the Mind," *Quantum,* vol. 4, no. 1 (Spring 1987), pp. 8–11.

54

AGNES PELTON (1881 – 1961)

55

Purple Star Icon, 1936

oil on artist's board

12¹¹⁄₁₆ × 8½ in.

(32.2 × 21.7 cm)

inscribed on reverse:

Purple Star Icon/by/

Agnes Pelton

Agnes Pelton was the oldest member of the TPG and the only one who did not live in New Mexico during the years the group was active. Nevertheless, she came to hold a place of honor among the group, owing, in part, to her independent search for a spiritual expression in art. Born of American parents in Stuttgart, Germany, she settled in New York with her mother about 1890, after her father's death. She studied at the Pratt Institute and privately with Arthur Dow. His teaching of decorative styles of Japanese art and of non-naturalistic use of color, as well as his assertion of the emotive and imaginative potentials in art over purely literary or narrative elements, were lasting influences on Pelton. Study abroad of French Symbolism and Italian classicism in 1909 also helped shape her interest in symbolic color and simplified compositions. She described her works of the 1910s as "imaginative painting;" in these she explored lighting effects, largely in the drapery of nymphlike maidens in landscape settings. In 1913, at the invitation of Walt Kuhn, she exhibited two such works in the Armory Show, a landmark exhibition that brought widespread public attention to European and American modern art.

Pelton's association with the TPG evolved through her friendship with one of its cofounders, Raymond Jonson. Just when and how they became acquainted is unclear. By 1933, when he organized a joint exhibition of their work – along with watercolors by modernist Cady Wells – at the Museum of New Mexico in Santa Fe, Jonson and Pelton had begun their long-term correspondence. Though the two had not yet met face to face, Jonson wrote Pelton in 1933 of his deep admiration for "the complete spiritual expression" of her paintings,[1] and in August 1938 he nominated her for TPG membership. Although Pelton had moved in 1926 to the seclusion of the desert near Cathedral City in southern California, where she lived the last thirty-five years of her life, she participated, nevertheless, at Jonson's encouragement in many TPG shows, and she was voted honorary chairman of the group.

In the mid 1920s Pelton began developing her first "symbolic abstractions," which she described as "little windows, opening to the view of a region not yet much visited consciously or by intention . . . [and revealing] an inner realm, rather than an outer landscape."[2] However, even in these characteristically mature works, Pelton never achieved a fully nonobjective style. Though these intimate, yet visionary, compositions were inspired by the landscape, they transcended the physical nature of the real world, suggesting universal themes. Composed of cosmic or heavenly connotations inspired by her interest in theosophy and mysticism, these highly personal works – such as *Purple Star Icon* – convey poetic, mystical moods enhanced by Pelton's continuing exploration of the expressive potential of color and radiant light. Documented in a sketchbook entry of July 12, 1936, *Purple Star Icon* is in all probability set at twilight, a time Pelton found particularly evocative because of its quality of light, which she often conveyed in a deep royal blue. Darkness pervades, but the star provides a beacon of hope and optimism, a theme that permeates much of her mature work and is reflected frequently in her choice of titles. Although Pelton achieved a measure of recognition through exhibitions of her work well into the 1940s, she died relatively forgotten and in poverty.

Notes

1 Letter from Raymond Jonson to Agnes Pelton, Aug. 17, 1933; Jonson Papers, Archives of American Art.
2 Statement in *Abstractions by Agnes Pelton* (exh. cat., New York: Montross Gallery, 1929), n.p.

Selected References

Perlmutter, Penny L. "Toward the Light: Agnes Pelton's Transcendental Paintings," *Antiques and Fine Arts,* vol. 7, no. 3 (Mar.–Apr. 1990), pp. 93–99.

Stainer, Margaret; et al. Agnes Pelton (exh. cat.). Fremont, California: Ohlone College Art Gallery, 1989.

HORACE TOWNER PIERCE (1916 – 1958)

56

Ellipsis, 1939

tempera on masonite

45 × 40 in.

(114.3 × 101.6 cm)

signed and dated at lower

right: *Pierce '39*

Horace Towner Pierce was a young, idealistic student of Emil Bisttram's when he joined the TPG in the summer of 1938. He was born on his family's ranch in Meeker, Colorado, and was raised by his grandmother following his mother's death in 1918. When his father remarried in 1925, the Pierces moved to Baltimore, and Horace attended Westtown School, a Quaker preparatory school in West Chester, Pennsylvania; he graduated in 1935. For the next several months he attended the Maryland Institute of Art. In early September 1936, Pierce arrived in Taos, where he studied with Bisttram for the next three years. There, he also met fellow student Florence Miller, whom he married in 1938.

With little previous formal training, Pierce was immediately indoctrinated through Bisttram's rigorous curriculum into the search for higher, non-objective art that reached "beyond the realm of experience or sense impressions... [and was based] on a spiritual intuition of reality, surpassing the bonds of sensorial experience."[1] By 1938, he had developed a visual vocabulary predicated upon primary geometric shapes such as the circle and the spiral, for the purpose of expressing universal themes. Pierce believed that in the future the media of motion pictures and television would replace painting. During the winter of 1938 and 1939 he worked on what would become one of his most important endeavors, an abstract movie – *The Spiral Symphony* – which he envisioned would be animated in color and accompanied by a musical score by the avant-garde composer and TPG publicist Dane Rudhyar. Pierce produced thirty small paintings for this eight-minute, four-movement production; in these he visually conceptualized four symbolic stages of life: birth, crystal growth, flower formation, and death.[2] In September 1939 Pierce and Miller became the first members to leave the TPG, departing Taos for New York City in order to seek funds to produce the movie. Though Pierce never secured those funds, his paintings for the film were exhibited in April 1940 at the Museum of Modern Art in a group show, *American Design for Abstract Films.*

Pierce painted *Ellipsis* during the time he was preoccupied with his animated film, and it relates in technique and motif to paintings of the score's final movement. Under the influence of Bisttram and perhaps also of Raymond Jonson, Pierce began using an airbrush about 1938, spraying paint to create soft modulations in color. This became an important tool for both Pierce and Jonson because it minimized any trace of the artist's hand and transformed the art of painting from a physical act to a metaphysical process.[3] The precision of the airbrush technique suited the mathematical or scientific tone of *Ellipsis,* which suggests Pierce's awareness of the constructivist aesthetic of Moholy-Nagy and Lissitzky. Layers of blue, red, and white were airbrushed, creating patterns that convey the axial rotation of the planetary body.

About 1942, pursuing his interest in motion pictures, Pierce moved his family to Los Angeles. He was drafted, but was soon released from the service because of health problems, which plagued him for the remainder of his life. Finally, disillusioned with the film industry, the Pierces returned to Santa Fe, where they opened a textile design firm. When that failed, Pierce worked as a technical illustrator for the United States Army Corps of Engineers, and he painted as time permitted until he died of a cerebral hemorrhage in 1958.

Notes

1 Pierce used these words to describe the aims of the TPG in his article "The Transcendental Painting Group is Introduced to Taos," *Taos Review,* Sept. 15, 1938. Very little about him has been published; much of the biographical material in this entry was provided by his wife, Florence Miller Pierce, in a taped interview with Susan E. Strickler, Nov. 13, 1990.

2 All thirty paintings are now in the Jonson Gallery, University of New Mexico, Albuquerque. Six are illustrated in *Bulletin of the Museum of Modern Art,* vol. 8 (April 1940), p. 8. In 1949 he painted a series of small watercolors for a second film, which also was never produced.

3 MaLin Wilson, former curator of the Jonson Gallery, has often pointed out this metaphoric use of the airbrush by Jonson and Pierce.

56

STUART WALKER (1904 – 1940)

57

Composition 2A, 1938

oil on canvas

36 × 30 in.

(91.4 × 76.2 cm)

signed on reverse over

sketch of TPG emblem:

COMPOSITION/

NUMBER "2A"/STUART/

WALKER/9 '38/-9-/#2A

Although Stuart Walker was an original member of the TPG and an artist highly regarded by his associates, chronic ill health kept him from fully participating in the activities of the group. He arrived in Albuquerque in 1925 seeking a mild climate for his fragile constitution, which seemed to be the result of a heart condition. A native of Kentucky, Walker had studied at the John Herron Art Institute in Indianapolis and with illustrator Frank Schoonover in Wilmington, Delaware.[1] Until about 1930 he produced representational landscape and floral compositions, often of southwestern subjects, in oil and watercolor. In Albuquerque, with friend and fellow artist Brooks Willis, Walker also operated a commercial art studio that produced greeting cards. During the late 1920s and 1930s he formed close associations with several artists in Albuquerque and Santa Fe who worked in modernist styles; they included Gina Knee, James Morris, and William Lumpkins, who became a fellow TPG member.

Walker turned from regionalist subjects to a nonobjective mode in the early 1930s by abstracting conventional landscape motifs. He developed a distinctive style concerned with strong, structural designs of interlocking geometric forms, which he painted in his characteristic palette of softly modulated pastels – beige, pink, purple, and blue – influenced by the colors of the desert. He began choosing neutral titles in order to free his paintings from any association with the physical world. Walker set himself apart from most of his fellow TPG members by eschewing any religious or mystical implication in his work, which he once described as "purely decorative."

Composition 2A, which was exhibited in 1939 in the TPG show at the Museum of New Mexico in Santa Fe, typifies Walker's mature nonobjective work. In a generally late cubist manner it combines rhythmic elements of active contours with more architectural forms. Although Walker apparently articulated little about aesthetic influences, this composition of generalized volumes and transparent, layered planes suggests the artist's interest in Purism and other derivative modes of Cubism. Unfortunately, Walker's career was soon cut short. Too sick to paint for any extended period of time during the last few years of his life, he died at the age of thirty-six, leaving a small body of work.

Walker's friend Raymond Jonson organized a memorial exhibition, for which he and Walker's widow prepared the most complete listing of the artist's oeuvre.[2]

Notes

1 A handwritten, undated biographical statement prepared by the artist provides some details previously unrecorded; the copy in the files of Penny and Elton Yasuna was provided to them by James Moore, Director, Albuquerque Museum. This statement appears to have been one of several by various TPG members; the statements were collected by Dane Rudhyar about 1938 or 1939.
2 This typewritten list is in the files of the Jonson Gallery, University of New Mexico, Albuquerque.

Selected References

Fort, Ilene Susan. "Arts Reviews: Stuart Walker," *Arts Magazine* (May 1981), pp. 28–29.
Mecklenburg. *Frost Collection,* pp. 184–85.

SELECTED GENERAL BIBLIOGRAPHY

American Abstract Artists

American Abstract Artists: Fiftieth Anniversary Celebration (exh. cat.). Bronx and Brookville, N.Y.: The Bronx Museum of the Arts and Hillwood Art Gallery, Long Island University, 1986.

Progressive Geometric Abstraction in America 1934–1955: Selections from the Peter B. Fischer Collection (exh. cat.). Clinton, N.Y.: Fred L. Emerson Gallery, Hamilton College, 1987.

American Abstract Artists. *American Abstract Artists 1936–1966*. Introduction by Ruth Gurin. New York: Ram Press, 1966.

————. *American Abstract Artists, Three Yearbooks (1938, 1939, 1946)*. New York: Arno Press, 1969.

*Berman, Greta. *The Lost Years: Mural Painting in New York City Under the WPA Federal Art Project, 1935–1943*. New York: Garland Publishing, 1978.

*Lane, John R.; and Susan C. Larsen, eds. *Abstract Painting and Sculpture in America 1927–1944* (exh. cat.). Pittsburgh and New York: Museum of Art, Carnegie Institute, in association with Harry N. Abrams, 1983.

*Larsen, Susan C. "The American Abstract Artists Group: A History and Evaluation of Its Impact upon American Art" (Ph.D. diss.). Evanston, Ill.: Northwestern University, 1975.

*Lizza, Richard William. "The American Abstract Artists: Thirties' Geometric Abstraction as Precursor to Forties' Expressive Abstraction" (Ph.D. diss.). Gainesville: Florida State University, 1985.

Marter, Joan, ed. *Beyond the Plane: American Constructions 1930–1965* (exh. cat.). Trenton: New Jersey State Museum, 1983.

*Mecklenburg, Virginia M. *American Abstraction 1930–1945: The Patricia and Phillip Frost Collection* (exh. cat.). Washington, D.C.: National Museum of American Art, Smithsonian Institution, 1989.

O'Connor, Francis V., ed. *The New Deal Art Projects: An Anthology of Memoirs*. Washington, D.C.: Smithsonian Institution Press, 1972.

————. *Art for the Millions*. Greenwich, Conn.: New York Graphic Society, 1973.

Tritschler, Thomas. *American Abstract Artists* (exh. cat.). Albuquerque: University Art Museum, University of New Mexico, 1977.

Troy, Nancy J. *Mondrian and Neo-Plasticism in America* (exh. cat.). New Haven, Conn.: Yale University Art Gallery, 1979.

Transcendental Painting Group

*Coke, Van Deren. *Taos and Santa Fe: The Artist's Environment*. Albuquerque: University of New Mexico Press, 1972.

*Eldredge, Charles C.; *et al*. *Art in New Mexico, 1900–1945: Paths to Taos and Sante Fe*. Washington, D.C. and New York: National Museum of American Art and Abbeville Press, 1986.

*Hay, Robert Charles. "Dane Rudhyar and the Transcendental Painting Group of New Mexico, 1938–1941" (M.A. thesis). East Lansing: Michigan State University, 1981 (reprinted by University Microfilms International, Ann Arbor, Michigan).

Monte, James; and Anne Glusker. *The Transcendental Painting Group: New Mexico 1938–1941* (exh. cat.). Albuquerque: Albuquerque Museum, 1982.

Morang, Alfred. *Transcendental Painting Group*. Sante Fe: American Foundation for Transcendental Painting, 1940.

*Udall, Sharyn Rohlfsen. *Modernist Painting in New Mexico, 1913–1935*. Albuquerque: University of New Mexico Press, 1984.

134

INDEX